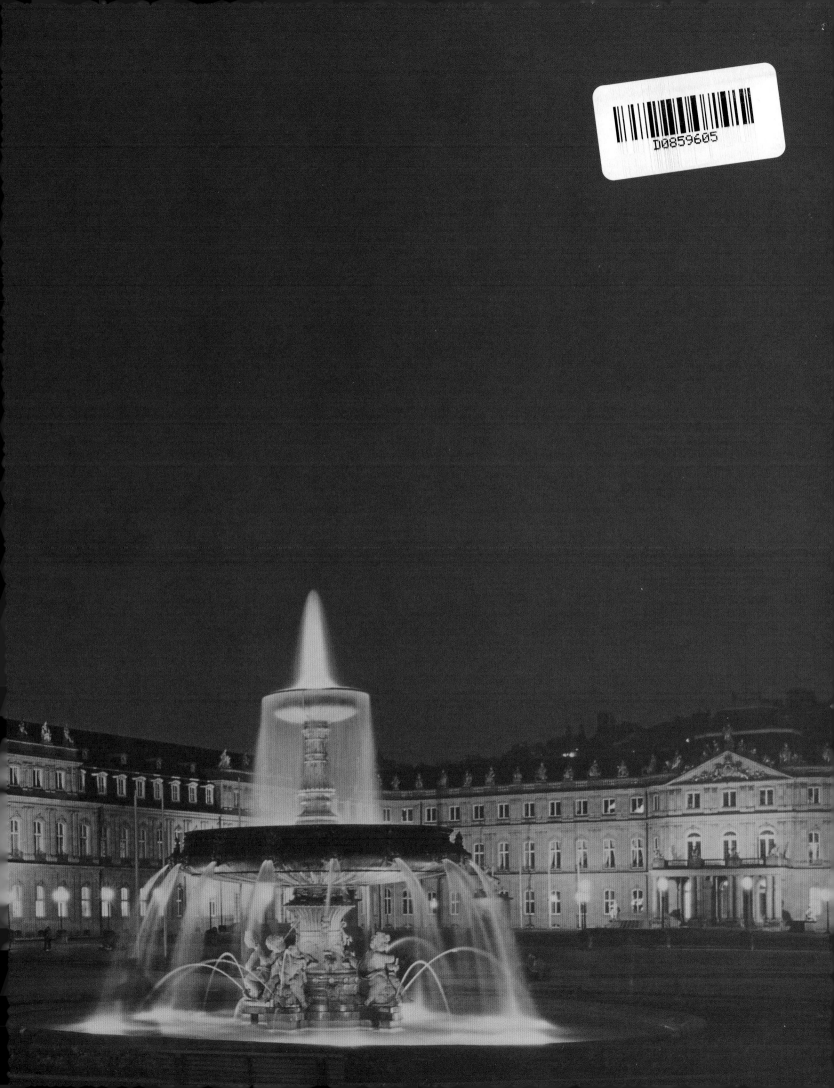

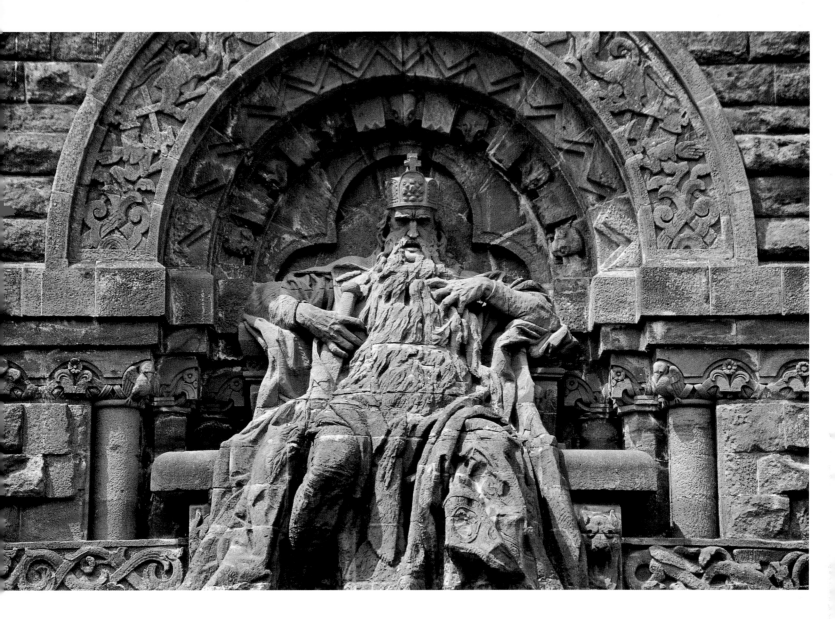

FASCINATING

GERMANY

PHOTOS BY

TINA AND HORST HERZIG

TEXT BY

SEBASTIAN WAGNER

FLECHSIG

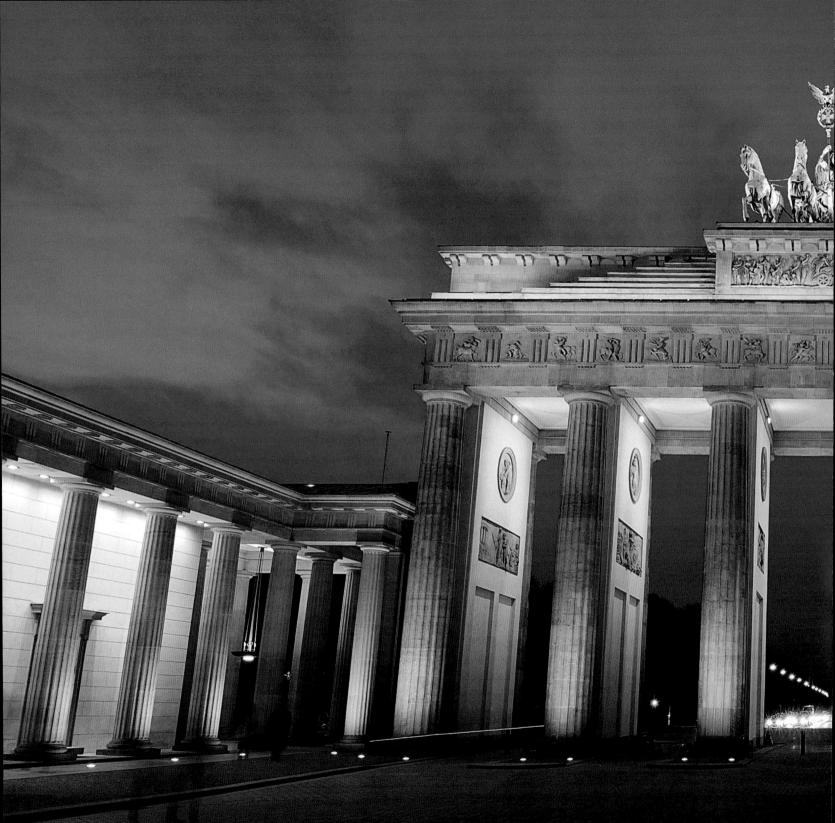

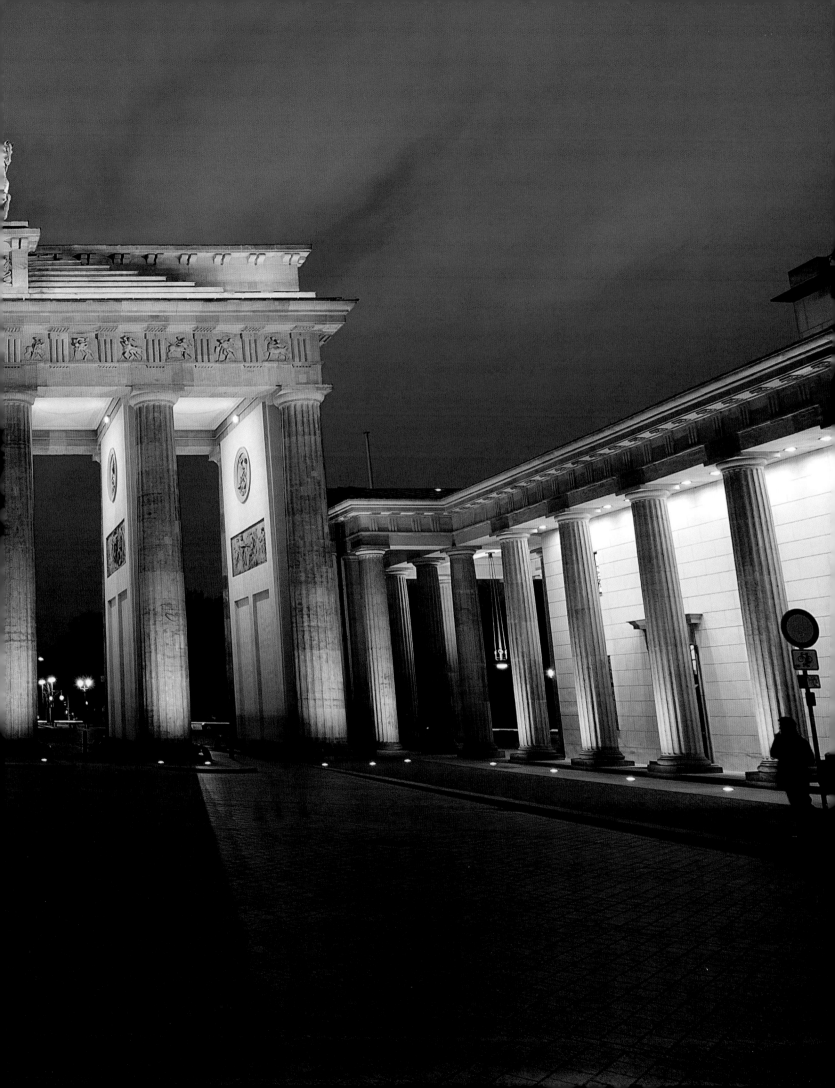

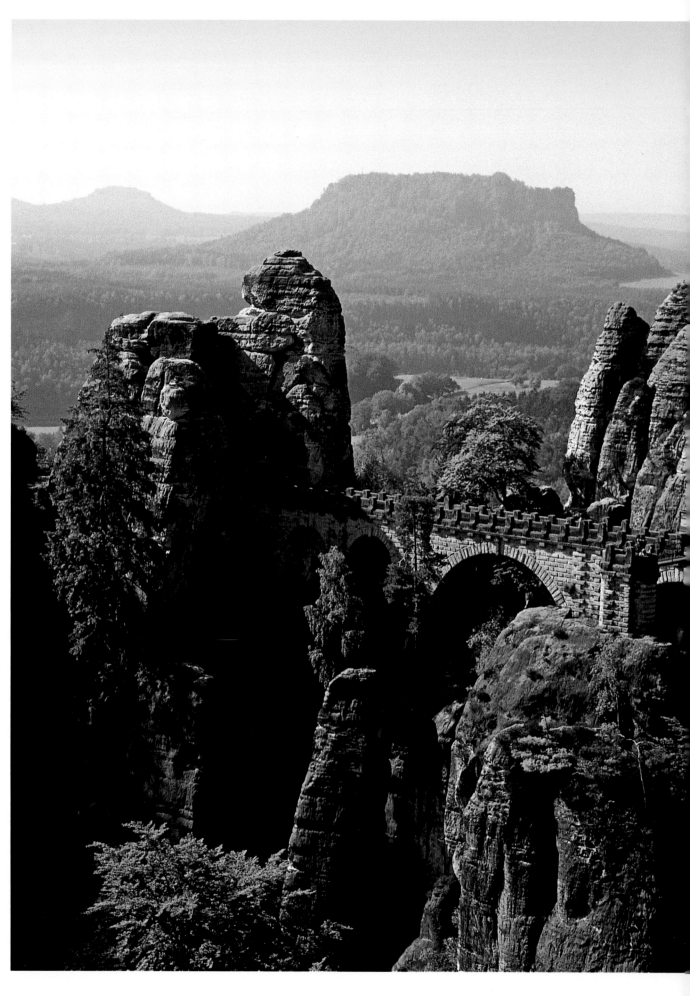

First page:
The Kyffhäuser, a low mountain ridge on the border of Thuringia and Saxony-Anhalt, is famous for its monument to Emperor Frederick Barbarossa I. Legend has it that Barbarossa and his entourage are fast asleep inside the hill, one day to awaken and restore the empire to its former glory.

Previous double spread:
The Brandenburg Gate symbolises both the division and reunification of Germany. Until 1990 it stood on the boundary between the two German states. The end of 1989/beginning of 1990, when the two Germanys celebrated their final coming together here, will remain imprinted on the minds of many forever. The Gate was erected in honour of Karl Wilhelm Ferdinand between 1788 and 1791.

Right:
The sandstone elevations of the Elbsandsteingebirge with their bizarre rock formations and dense forest were named "Saxon Switzerland" or Sächsische Schweiz in the 18th century. The Basteibrücke spans a yawning crevice over the Elbe and affords fabulous views out across the river and distant hills.

Page 10/11:
View of the ancestral seat of the Hohenzollerns, 855 metres (2,805 feet) above sea level in the west of the Swabian Alb, surmounted by its neo-Gothic castle. Ca. 500,000 visitors a year make the long climb up to the top to marvel at the mock-medieval fantasy of Burg Hohenzollern created by "a Prussian crown prince and his architects and interior designers" in 1867.

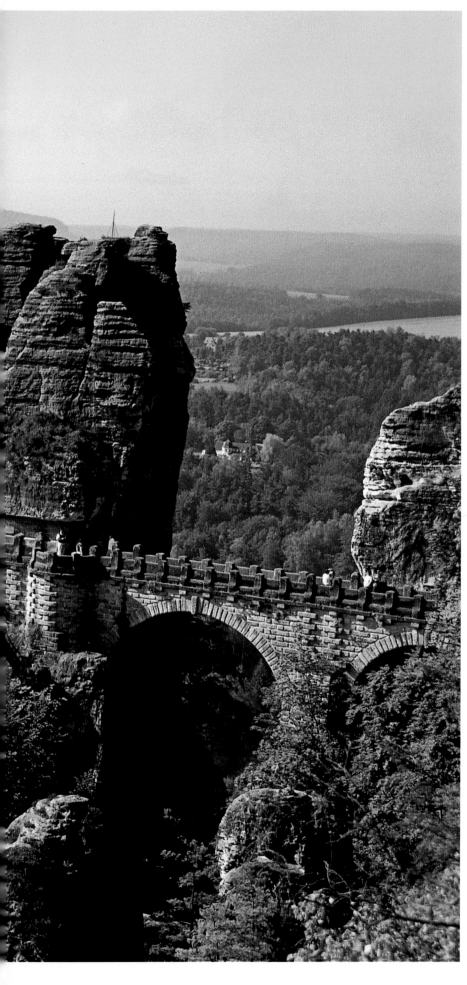

INHALT

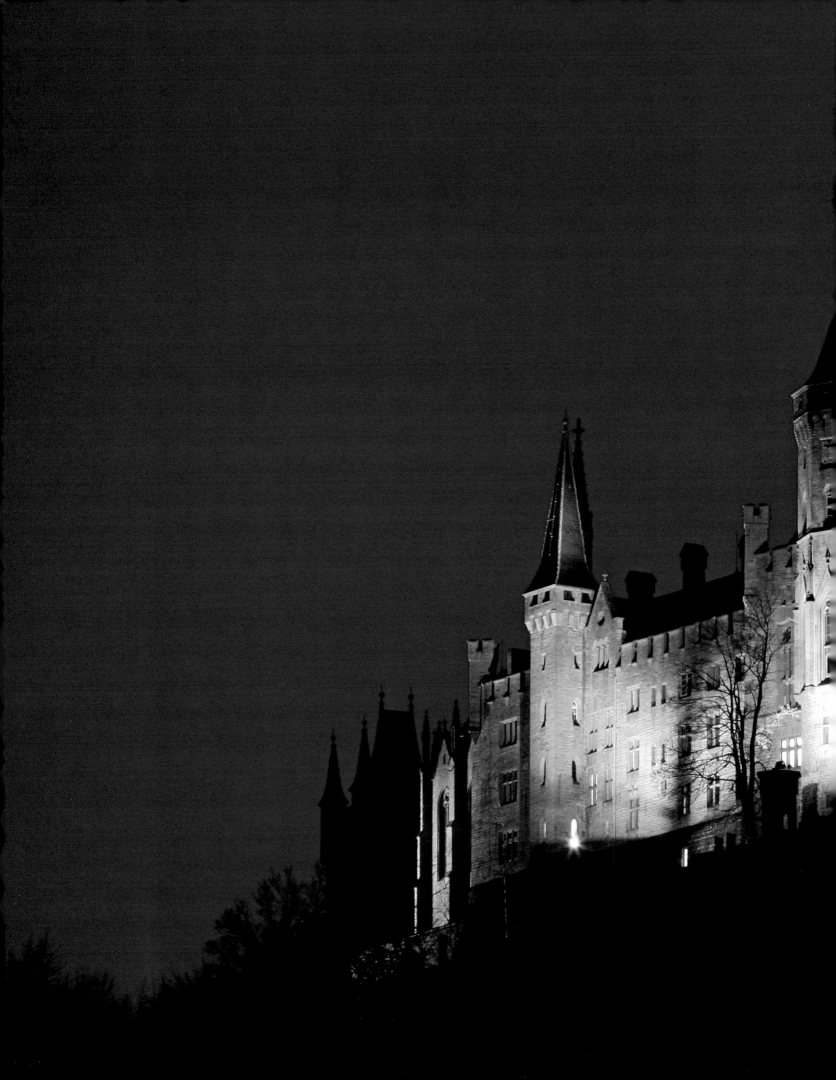

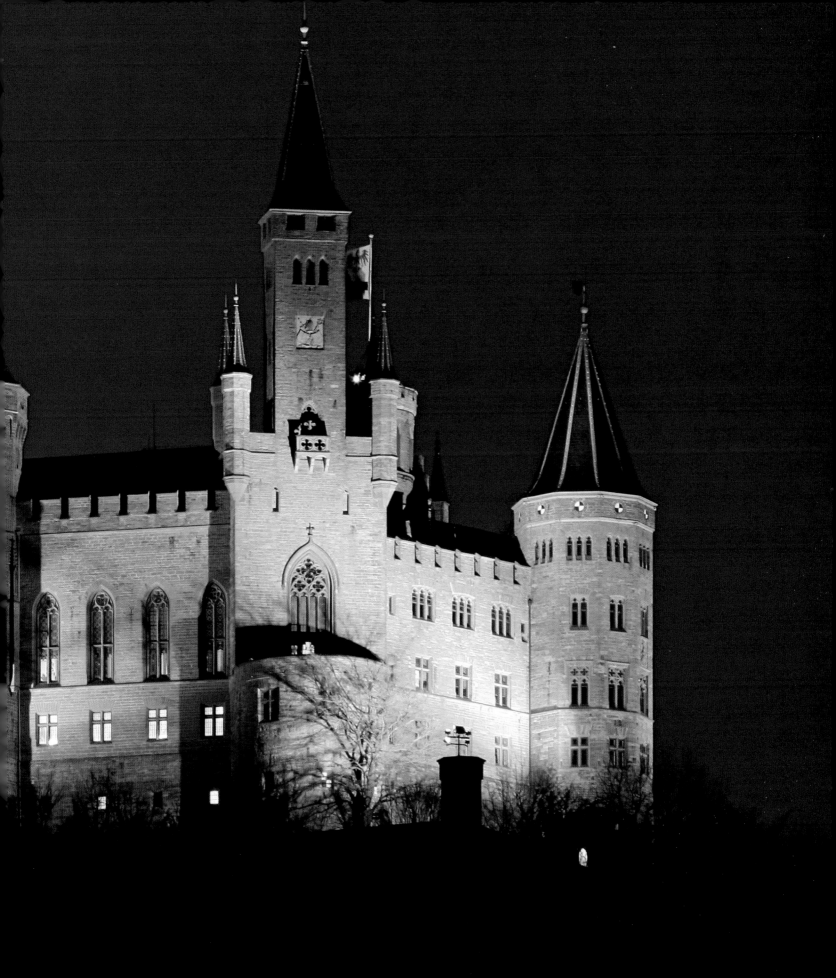

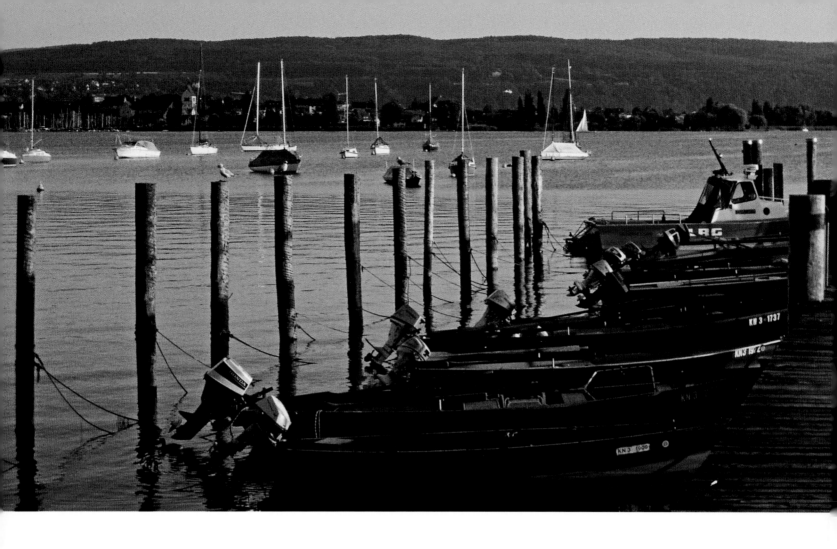

IN THE HEART OF EUROPE – GERMANY

Germany: since when, exactly, has it existed? Let's start at the very beginning. At the transition from BC to AD there were no determinable national structures, with 'Germany' merely a region populated by numerous independent Germanic clans. These gradually banded together to form the larger tribes of the Franks, Saxons and Alemanni. From the 3rd to the 6th centuries AD the first political entities were formed, loose associations of peoples bound together by shared traditions rather than organised duchies or kingdoms. It wasn't until the 8th cen-

tury and Emperor Charlemagne that a common enti[ty] emerged with the founding of the Frankish Empire. Th[is] wasn't to last; in 843 at the Treaty of Verdun Charl[e]magne's grandsons split the empire into two administr[a]tive units, with the area east of the Rhine and Aa[r] rivers or the East Frankish Kingdom falling to Ludw[ig] the German. After much confusion, the crowning [of] Conrad I as king of the East Franks in 911 and the ensui[ng] Declaration of Indivisibility, in 920 the first menti[on] is made of a Regnum Teutonicum or German Empi[re.] Only in the Middle High German period (1050–135[0]) did the expression *das deutsche Land* (the country of G[er]many) begin to find any currency, eventually becomi[ng] *Deutschland* in the 16th century.

Martin Luther's 95 Theses

The Middle Ages drew to a close in c. 1517, making w[ay] for what historians have categorised as the modern e[ra,] the age of great discovery, humanism and the Renaissan[ce.] Europe began redefining mankind and the world [it] inhabited. The initiator of this new epoch was the mo[nk] Martin Luther who in 1517 published his 95 *Theses* [on] the selling of indulgences; whether he actually nail[ed] them to the door of the church in Wittenberg or not, [his] revolutionary ideas set the wheels of the Reformation [in] motion, causing the foundations of the medieval wo[rld] order to slowly crumble.

In the wake of hefty fighting between the warring fa[c]tions of the Protestant Union and the Catholic Leag[ue]

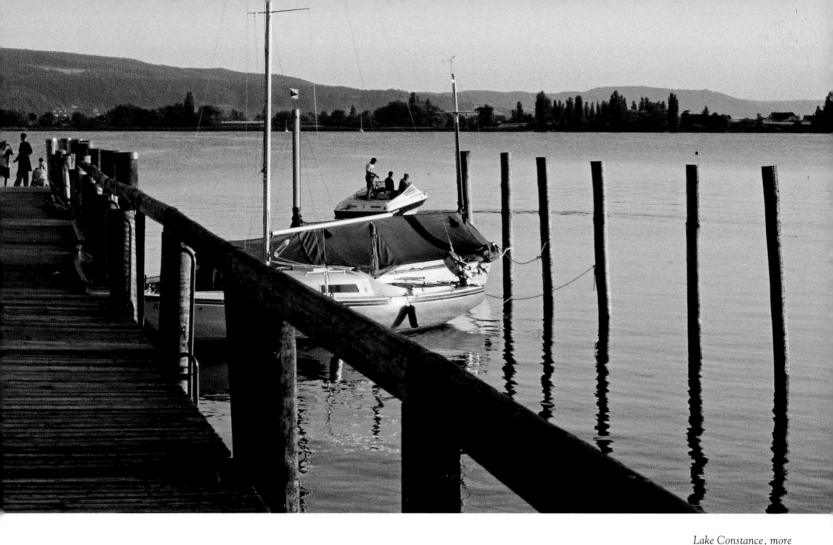

rope was dragged into the Thirty Years' War which
tally depopulated entire regions of Germany. Follow-
g the famous "defenestration" episode in Prague in 1618
e massacre began. After four long years of negotiation
e conflict was ended in 1648 at the Congress of West-
alia which reaffirmed the religious state of play of 1624
d officially recognised the Protestant confession. Ex-
sive territorial settlements were also made, in which
sace fell to the Habsburgs, Pomerania and Wismar
re given to the Swedes and the Upper Palatinate was
nted to Bavaria. A further outcome of the Peace of
estphalia was the legalisation of the 300 German
tes under autonomous rule. By the mid 17th century, the
ification of Germany seemed to be a completely lost
use.

age of absolutism followed where local potentates
t themselves beyond the law, resulting in all kinds of
vernment imaginable across the chaotic map of what
n only loosely be termed Germany. Here, too, it can
observed that extremes gave rise to contradiction.
m the middle of the 18th century on a form of classic
erature emerged which blossomed towards the end of
e century in the works of Goethe, Schiller and others.
e Romantic period dawned and with it the era of Ger-
n idealist philosophy.

The people take the political stage

e wars of liberation put an end to the havoc of the
nch Revolution and the rule of Napoleon, the most
famous battle being fought at Leipzig in 1813. After
Napoleon had finally been defeated the Congress of
Vienna was called into being, chaired by the prince of
Metternich, at which the political map of Central
Europe was redrawn. The Holy Roman Empire was
disbanded in favour of a German Confederation, a loose
alliance of states whose majority decisions were to be
reached by 37 sovereign princes and four free cities. This
confederation, however, came nowhere near to satisfy-
ing the national movement towards unity.

Liberalism was the new order of the day, championed by
broad sections of the bourgeoisie calling for political
freedom and the abolition of aristocratic privileges. The
movement's best-known and most publicity-geared
event was the festival of 1832 at Hambach Castle, a
mass rally in which over 30,000 took part and numerous
speeches advocating a free and unified Germany were
made. German parliament retaliated with total censorship
of the press and suppression of the freedom of assembly.
This was the era of poet Heinrich Heine, whose most
famous works include the *Buch der Lieder* (the Book of
Songs cycle, 1827) with his *Harzreise* (Harz Journey),
and *Deutschland. Ein Wintermärchen* (Germany. A Win-
ter's Tale, 1844). Following the publication of his biting
satire of conditions in Germany Heine's writings were
banned. He moved to Paris in 1831 where he died at 58.
The March Revolution of 1848, instigated by the bourgeois
middle classes, brought about the collapse of Metter-
nich's system of feudalism and led to the founding of a

*Lake Constance, more
small sea than lake in the
very south of Germany,
has always held a great
fascination. Its moods
have inspired many a poet
and painter, several of
whom settled here, among
them Otto Dix, Annette
von Droste-Hülshoff and
Hermann Hesse. Martin
Walser is now probably
the most famous writer
living here, with the lake
playing a key role in his
work.*

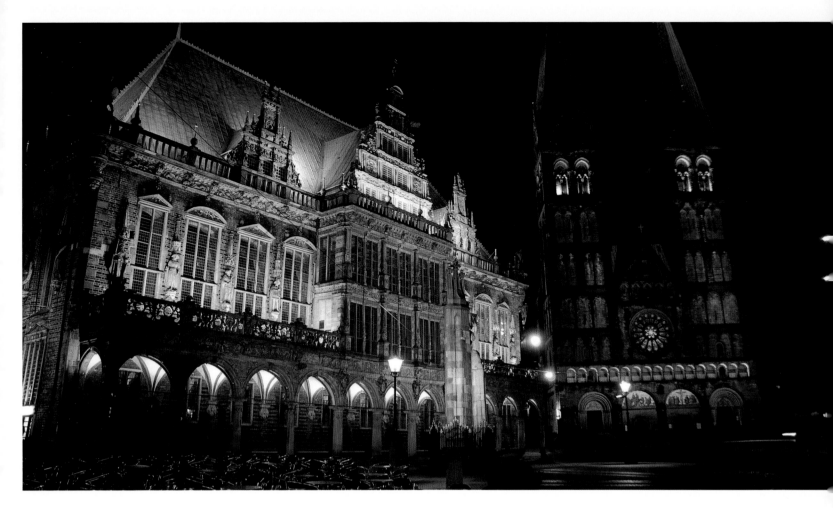

The Rathaus or town hall in Bremen, a Gothic brick building from 1410, was given its splendid Renaissance facade in 1612. In its great hall, reckoned to be one of the most sumptuous in Germany, a traditional banquet for ship owners and fishermen is held once a year. Next to the Rathaus are the steeples of the Lutheran cathedral. The Gothic hall church was once the seat of the archbishops of Bremen.

German National Assembly which met at the Church of St Paul's in Frankfurt. German unity now seemed to be within reach; a "bill on the fundamental rights of the German people" had even been agreed upon. Yet it was not to be; the designated emperor, the then king of Prussia Frederick William IV, refused the crown. The dream of a united nation was once again crushed – forever, it appeared, after troops from Württemberg stormed the parliament building in 1849. The status quo of the German Confederation was reinstated.

All seemed to be lost, yet hope was in sight in a very different guise. By the mid-19th century Europe was in the throes of a new, industrial revolution and by 1860 much of the country was linked by 6,000 kilometres (3,728 miles) of railway track. Germany was gradually unified by 'public' transport, forming a common market in the most modern sense of the word. The Franco-Prussian War of 1871 terminated in the establishing of a German Empire and, with Bismarck pulling the strings, of economic union of the many German states. There was now one Germany, one German nation which was able to exert international claims to power, to build up a network of colonies abroad and a naval fleet at home and – under the wilful leadership of Emperor William II – to slide headlong into the First World War. The public enthusiasm which greeted the Great War of 1914–1918 far exceeded that shown for almost any previous event in Germany's history. Eager to fight for the fatherland, men joined up in their thousands – and in their thousands they perished.

The Weimar Republic

The catastrophe of the First World War ended in t November Revolution of 1918, triggered by naval mutin in Wilhelmshaven and Kiel. Emperor William II w forced to abdicate and went into exile in the Neth lands where he became a country gent. Much to the a noyance of provisional head of state Friedrich Ebert t German Republic could now be proclaimed by Phili Scheidemann – with socialist Karl Liebknecht quick second the motion. Germany found itself in a turbule transition coloured by anarchism in all forms, from fu damental democracy to despotism. These 'soviet republi were soon usurped by the fated Weimar Republic ov seen by Ebert, the new president the people themsel had elected. Germany was now a democratic republ History could have taken a turn for the better had it been for the excessive weakness of the leading politi parties and hefty attacks on the government – akin civil war – from both left and right. This was compound by economic difficulties, these in turn heightened by t reparations demanded by the Treaty of Versailles.

Europe turns to dust

At the beginning of 1933 the darkest chapter in G many's history began. In the January 30 elections t National Socialists seized the parliamentary major and Adolf Hitler was made chancellor. His first deed office was to pass a series of emergency decrees and t infamous Enabling Act with which he could eradic:

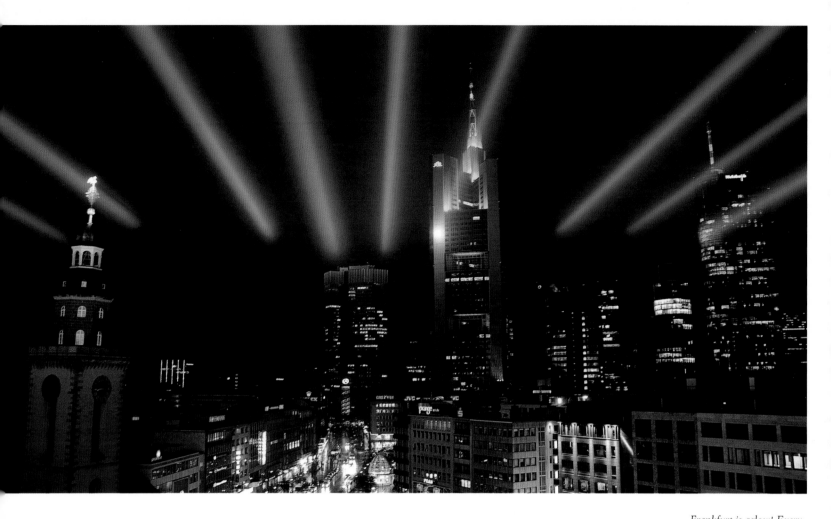

Frankfurt is aglow! Every two years Frankfurt am Main is the setting for Luminale, a veritable festival of light. During the event light art and light installations illuminate various public and private buildings and busy squares in and around Frankfurt.

opponents. Following Hindenburg's death in 1934 he claimed himself Führer and chancellor of the Reich, setting up a brutal, inhumane system of rule and abolishing many basic civil and human rights.

On September 1, 1939, Hitler began his blitz on Poland, signalling the beginning of the disastrous Second World War. This was followed by attacks on France, the Soviet Union, Belgium, Holland, Great Britain and others. Only after Hitler's suicide on April 30, 1945, and the capitulation of the Germans on May 7/8 of the same year did the war in Europe grind to a bloody close. The fighting and the Nazi reign of terror had claimed over 42 million lives. A further casualty was Bismarck's German nation state of 1871, now doomed to change forever.

In the aftermath of war Germany, like much of Europe, was totally devastated; millions of people had been displaced and the Allies – the USA, Great Britain, France and the Soviet Union – had split the country up into four zones of occupation governed by the Allied Control Council. The Treaty of Potsdam of August 2, 1945, again redefined Germany's borders, confiscating most of its eastern territories. One new boundary was still to come, however. Amidst growing conflict between East and West during the Cold War two socio-economic systems gradually emerged, cemented in 1949 with the establishment of the Federal Republic of Germany (FRG) and the German Democratic Republic (GDR). For the first time in history there were two German nations, with a frontier running slap bang through the middle of Berlin. At first

people were able to cross the great divide with relative freedom of movement; the erection of Berlin's "antifascist wall of protection" on August 13, 1961, however, hermetically sealed West Berlin off from the rest of the East overnight. Passage between the two fronts was now only possible via one of the seven zealously guarded border crossings, Checkpoint Charlie being the most well-known.

A wall through Germany

The capitalist FRG and the socialist GDR grew in completely different directions, making a peaceful coexistence practically impossible. The more positive economic development of the FRG prompted an increasing number of East Germans to emigrate to the West; the GDR retaliated by installing the Berlin Wall, a totally inviolable obstacle which remained in place until 1989.

With the manipulated local elections of May 7, 1989, the political climate within the GDR rapidly worsened. By the summer angry citizens had occupied West German embassies in Prague, Budapest and Warsaw, with a wave of refugees flooding across the open borders of the Eastern Block. After much intense diplomatic bartering West Germany's foreign minister Dietrich Genscher managed to gain permission for the asylum seekers to emigrate to the West. The groundbreaking news was departed to jubilant crowds in a famous speech Genscher delivered from the balcony of the Prague embassy. And within the GDR itself resistance was building up. What

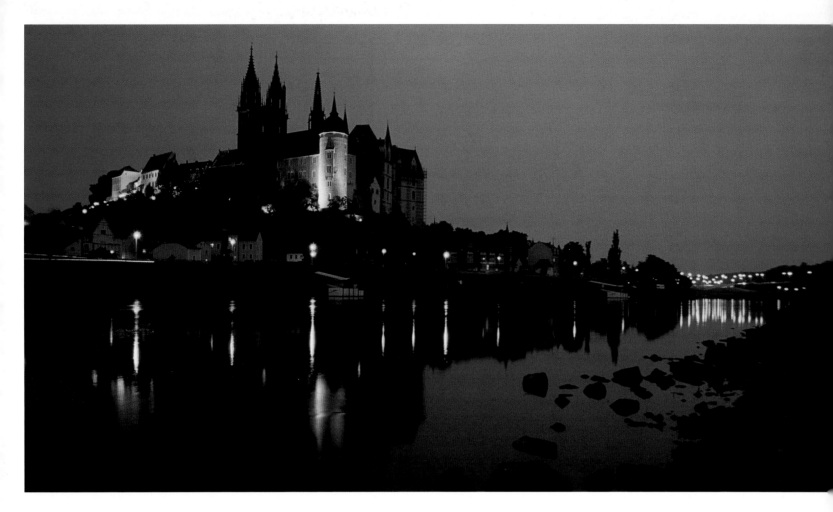

The history of Saxony
began 1,000 years ago
on the castle mound in
Meißen. The picturesque
silhouette is dominated by
the Gothic cathedral and
the late Gothic fortress
of Albrechtsburg. It was
within these walls that
Augustus the Strong had
the first bone china manu-
facturer's in Europe
opened in 1710.

Page 18/19:
Winter on the Alpsee in
the Allgäu. The dreamy
king of Bavaria Ludwig II
may have enjoyed many a
magnificent natural spec-
tacle such as this from the
west balcony of Schloss
Neuschwanstein. In the
foreground is Schloss
Hohenschwangau, built by
Ludwig's father, King
Maximilian II, as a sum-
mer residence for the royal
family. Ludwig spent his
childhood here – the
happiest years of his life.

became known as the Monday Demonstrations took place in several cities across the country, particularly in Leipzig, where on October 9 over 70,000 thronged the streets. Under the increasing pressure of both the public and the *Politbüro*, GDR head of state Erich Honecker stepped down and handed over to Egon Krenz.

Late in the evening of November 9, 1989, the Berlin Wall unexpectedly opened, rapidly followed by the GDR's many other borders; the population of the East promptly surged into the West. From this day forward there was no stopping the reunification of Germany; all danger of the army taking pot shots at demonstrators and potential defectors had finally passed. In retrospect it seems strange that the GDR regime should have been deposed in such an unpretentious manner. The government had been caught unawares; its lame inaction prevented the worst. Within a very short space of time the entire country had been turned upside down, its repressive machinery and state order completely paralysed down to the last infringement on the private individual. What had seemed impossible was now reality; thousands scrambled onto the Berlin Wall and began to chisel away at the concrete, demolishing the hated edifice before the very eyes of the GDR's border guards. The most impenetrable frontier in Europe, perhaps even in the world, was now the scene of merry destruction.

It wasn't long before the desire was expressed for Germany to once again become a unit, although the further existence of East Germany was also the subject of much

heated discussion. The two German states met t Allies of the Second World War in Moscow to negoti a possible solution. A unification treaty was signed August 30, 1990; the historic era of the GDR had co to an end. On October 3, 1990, now a national pub holiday, Germany was officially reunited.

Right page:
This monument to Goe
and Schiller outside the
Nationaltheater in Wei
was unveiled on Septem
ber 4, 1857, in memor
both the classical perio
Weimar and the friends
the two poets enjoyed.

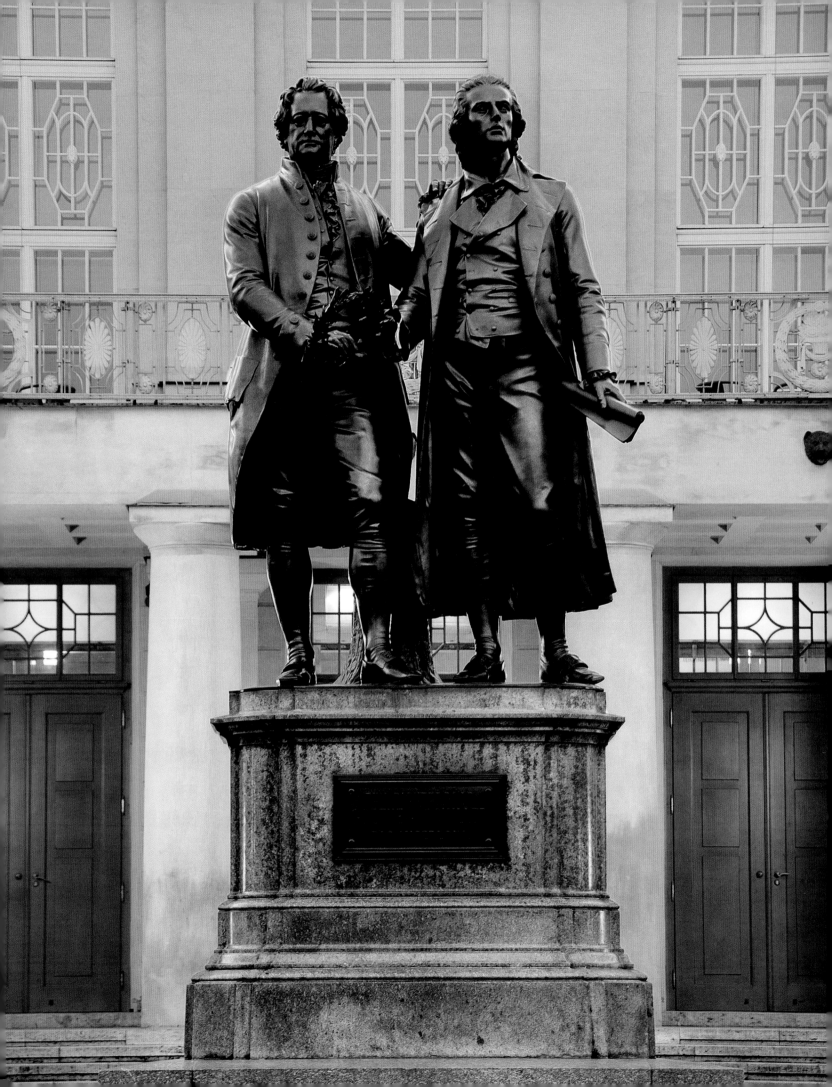

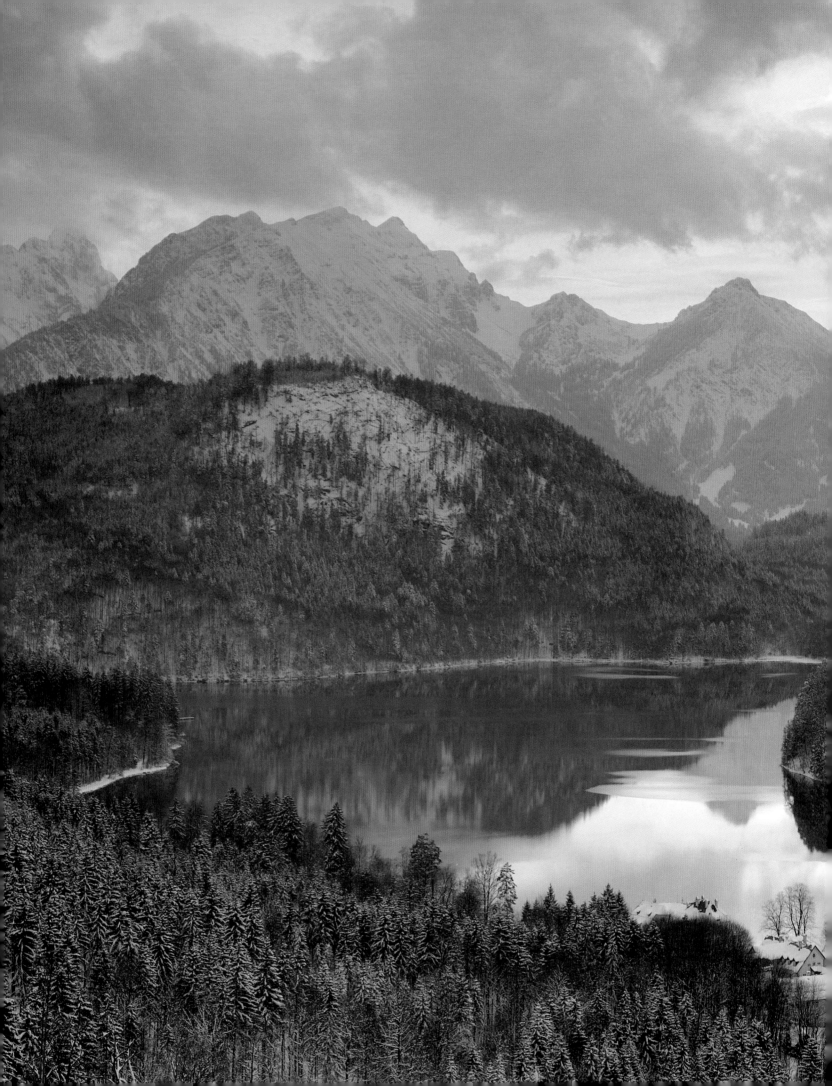

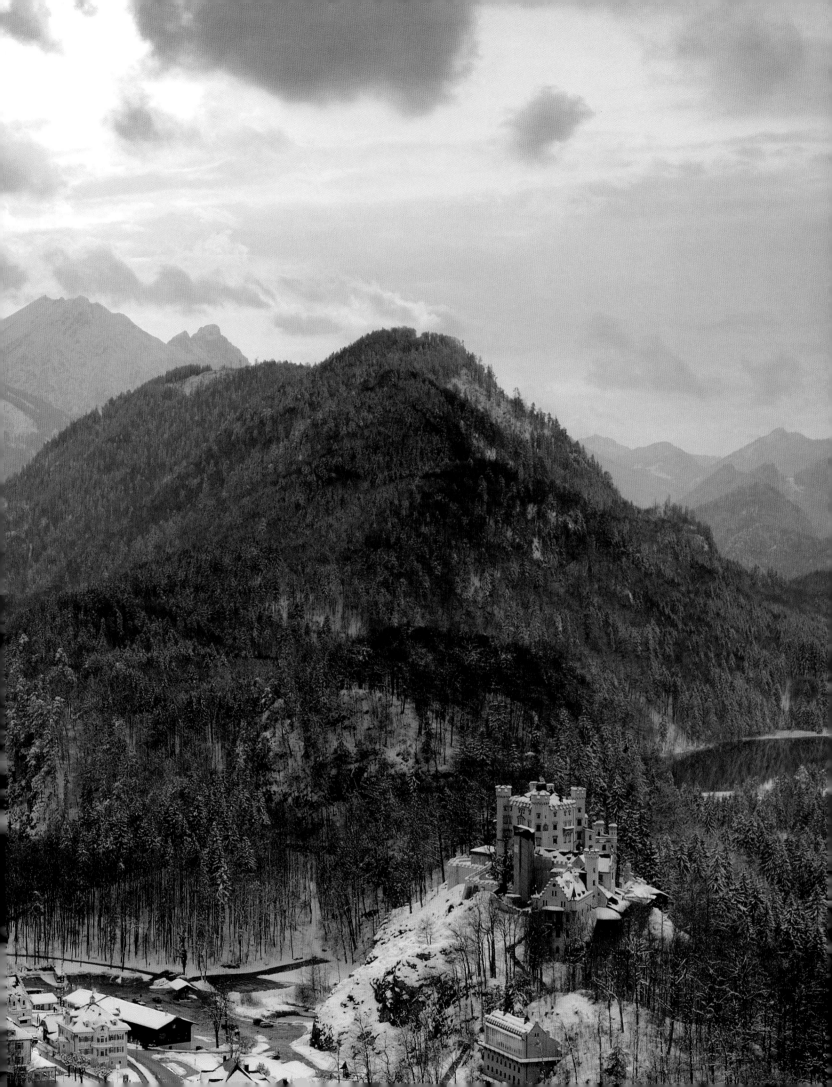

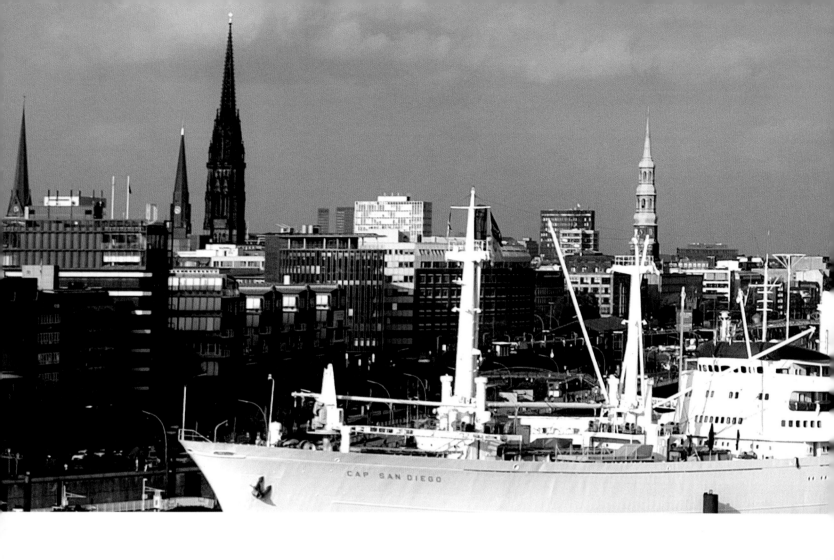

CAP SAN DIEGO

GERMANY'S NORTH – FROM THE COAST TO THE HARZ

Germany starts in Hamburg – at least it does if you approach by sea. The harbour is the largest in Germany and the city itself the nocturnal and cultural metropolis of the north. Hamburg's legendary reputation goes back to the days of the Hanseatic League; the economic power wielded by its harbour still brings prosperity to the entire region.

The city and suburbs of Hamburg spill out into the mo[re] rural areas of Schleswig-Holstein. The outposts of Ge[r]many's northernmost federal state are the storm-lash[ed] North Frisian Islands, from Amrum to Sylt, stranded o[ff]shore in the wild North Sea.

Where fishing only just kept the North Coast from st[ar]vation, foreign trade brought wealth to the Baltic. O[ne] of these cities is Lübeck, famous for its unique Goth[ic] brick architecture and as the setting for Thomas Man[n's] *Buddenbrooks*. Mann was born into a Lübeck merchan[t] family in 1875; his aforementioned novel won him t[he] Nobel Prize for Literature in 1929.

Bremen is another north German city to feature in t[he] world of literature. One of the famous fairytales by t[he] Brothers Grimm tells of the Bremen Town Band, a gro[up] of animals-cum-musicians who rose to fame through th[eir] cunning and intelligence. Their era seems to be evok[ed] still in the city's ancient Schnoor quarter, once inhab[it]ed by craftsmen and fishermen.

North Rhine-Westphalia is just as diverse, althou[gh] many immediately associate it with the history of t[he] Ruhr, Germany's chief industrial heartland. In fact alm[ost] half of the state is now farmed. The state boasts both t[he] provincial capital of Düsseldorf and media metropo[lis] Cologne, a humming national centre of economy a[nd] the arts.

20

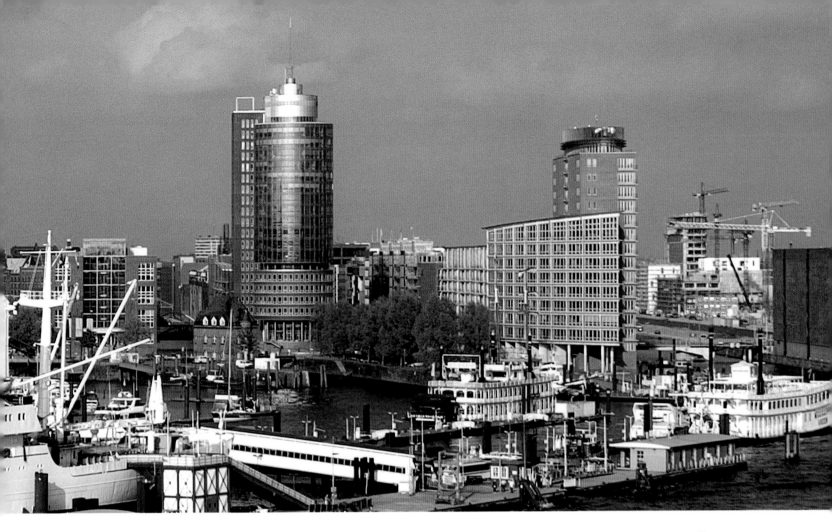

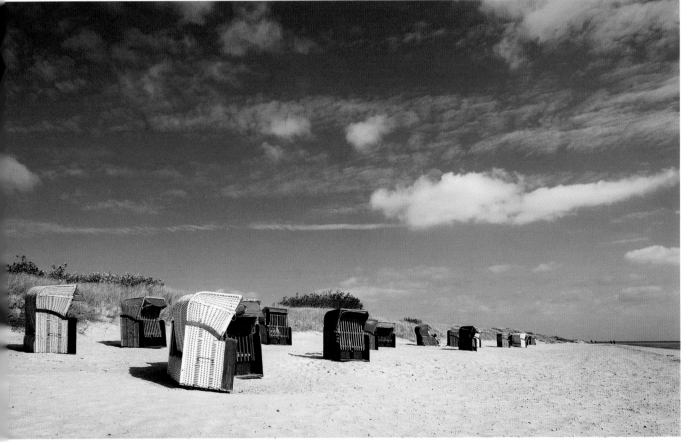

Above:
Life in Hamburg has been dominated by its harbour since the 12th century. Ships bound for the North Sea from Hamburg have to cover a long 104 kilometres (65 miles) along the River Elbe before hitting the ocean waves.

Left:
In 1882 Rostock basket weaver Wilhelm Bartelmann (1845-1930) made the first wicker beach chair for the rheumatic Elfriede von Maltzahn, who desired a comfortable place of repose whilst visiting the seaside resort of Warnemünde. The hooded armchair was immediately a roaring success and has since seated generations of holidaymakers.

Hallig Hooge is the second-largest of the Hallig Isles on the mudflats of Schleswig-Holstein. The houses are erected on artificial mounds or Warfte. Hallige Hooge has nine Warfte, one of which, Kirchwarft, houses the church of St John's. The place of worship was consecrated in 1637 and has a wonderful inventory which has been amassed over the years.

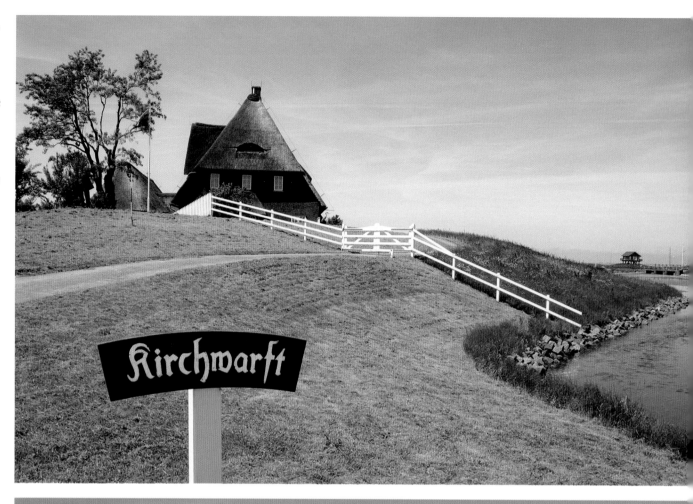

Each year since 1882 the last week in June has seen the event of the Kieler Woche. Over 2,000 boats and 5,000 sailors enter the regattas in every imaginable class of ship. The windjammer parade, in which up to 100 ships take part, is just one of the week's highlights. The photo shows the Alexander von Humboldt which was launched in 1907 and is anchored in the harbour at Bremerhaven.

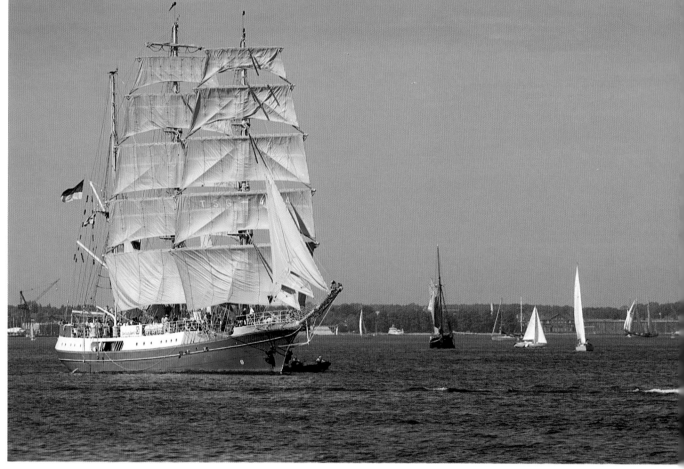

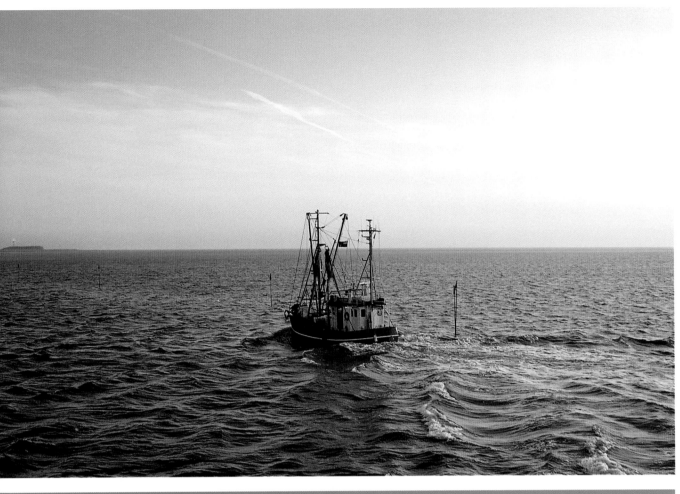

A shrimp cutter trawls the mudflats back to the harbour. North Sea shrimp are caught in nets dragged over the bottom of the ocean. As the catch can spoil very quickly, the shrimp are cooked aboard the boat in seawater which gives them their unique flavour.

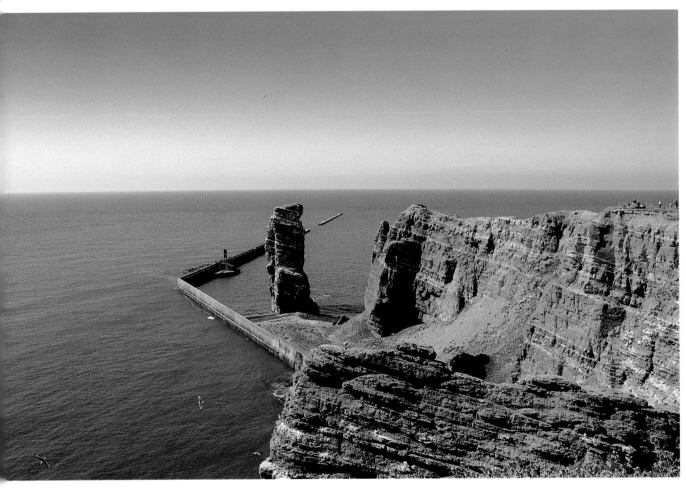

What Helgoland, the island rock in the middle of the North Sea, lacks in size, it makes up for in tourist magnetism and incredible scenery. The coastal path snaking along the top of the cliffs allows the many visitors to admire its bizarre rock formations from on high. "Lange Anna", a free-standing tower carved out of the island by the elements, is the island's local landmark.

In the early 20th century the Sankt-Pauli landing stages in Hamburg's harbour doubled as wharves for huge passenger steamships run by international shipping lines. Today the enormous floating structure is a tourist attraction and the perfect place from which to embark on tours of the harbour. At the west end of Sankt-Pauli is the entrance to the old Elbe tunnel, with the navigation tower showing the tide levels at the east end.

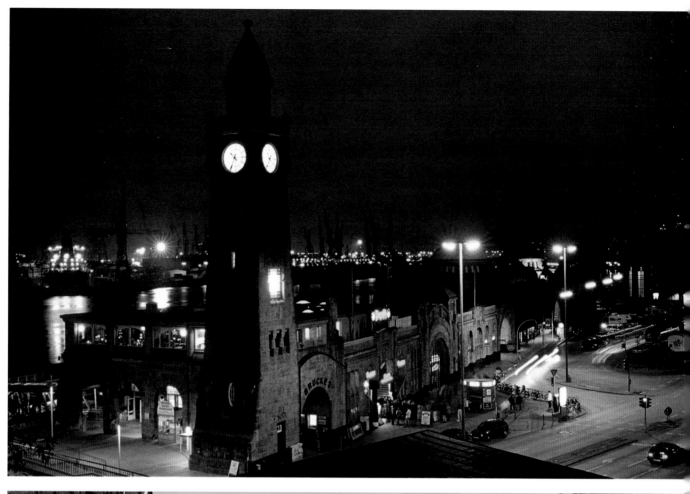

The Speicherstadt or warehouse district was set up in the late 19th century as a free port. The Fleeten (canals) are lined with brick buildings which stored coffee, tobacco, spices, carpets and all the other wares which arrived in Hamburg on ships from faraway places. Today many of the buildings have been converted into apartments and offices which are highly coveted in this exclusive location.

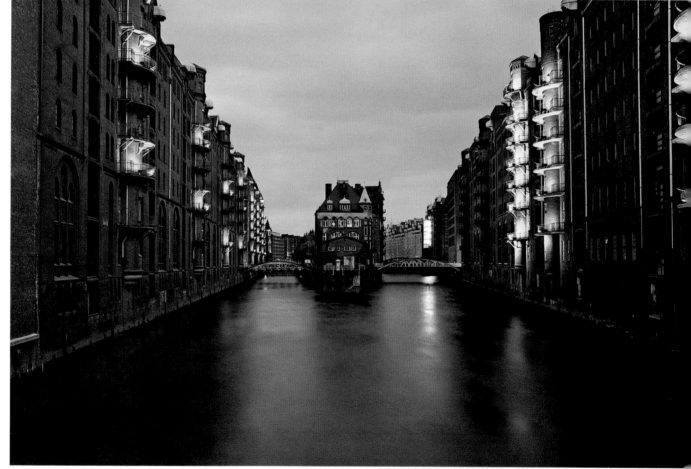

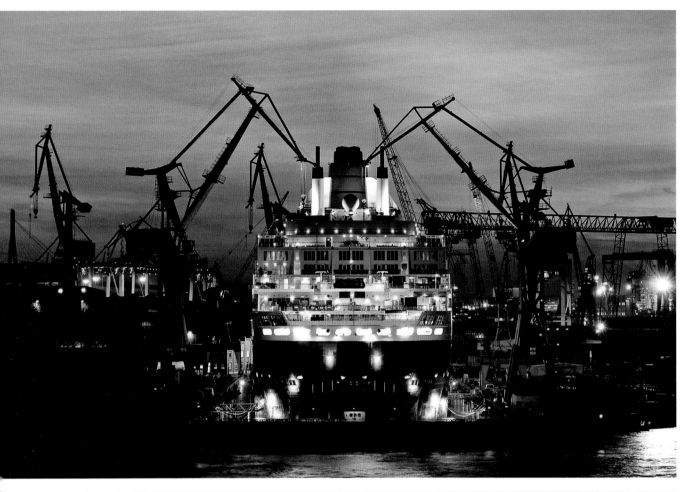

Shipping and ship maintenance still have a big part to play in Hamburg. The Blohm and Voss wharf has the best location on the landing stages where it overhauls ships from all over the world in its dry dock. Here the Queen Mary II.

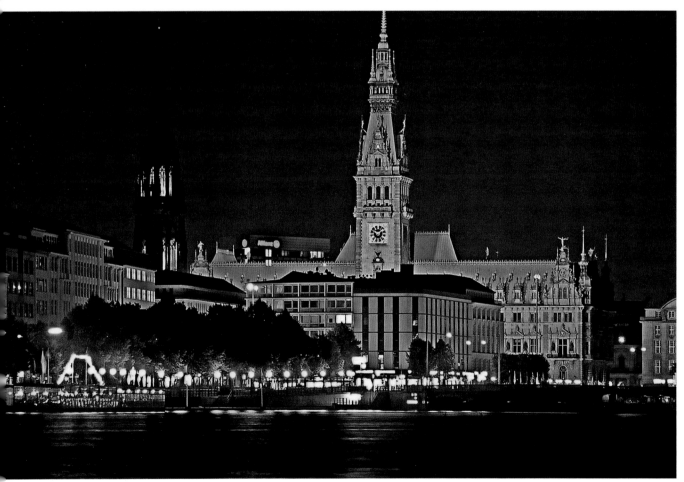

Hamburg's more picturesque attributes include the Jungfernstieg and Binnenalster lake, with the town hall (tower to the right) and steeple of St Nikolai (left). The city is encircled by water; where the Elbe is the scene of busy harbour activity, the Binnenalster, Hamburg's chic boulevard, bears elegant witness to the city's glorious Hanseatic past.

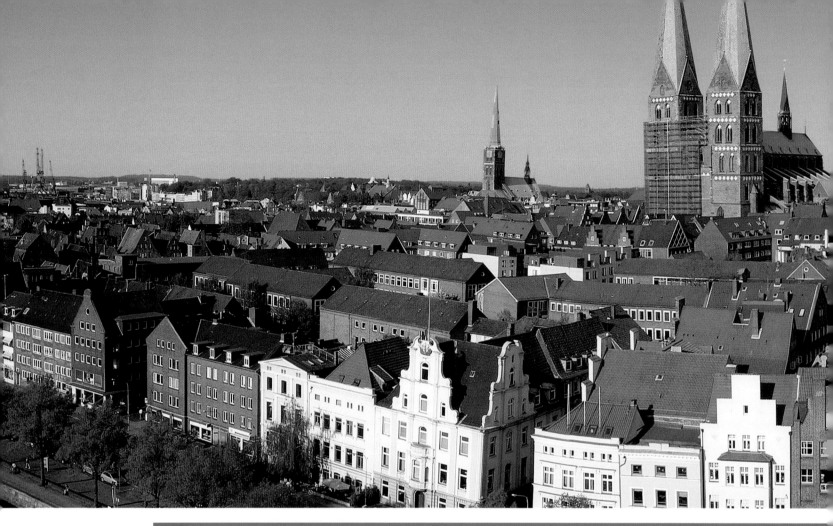

Above:
Lübeck was founded in 1143 and made a self-governing city under the emperor by Emperor Friedrich II in 1226. 500 prosperous years followed as 'queen' of the Hanseatic League and even today the city with its ferry port still sees itself as "the gateway to the north". This panoramic view takes in the city with its seven towers. Lübeck's unique and uniform townscape earned it a place on the list of UNESCO World Heritage Sites in 1987.

Right:
The mighty Holstentor is Lübeck's local landmark. The gate was completed in 1478 and was once part of the fortifications which protected the wealthy Hanseatic city. Today it accommodates the town museum.

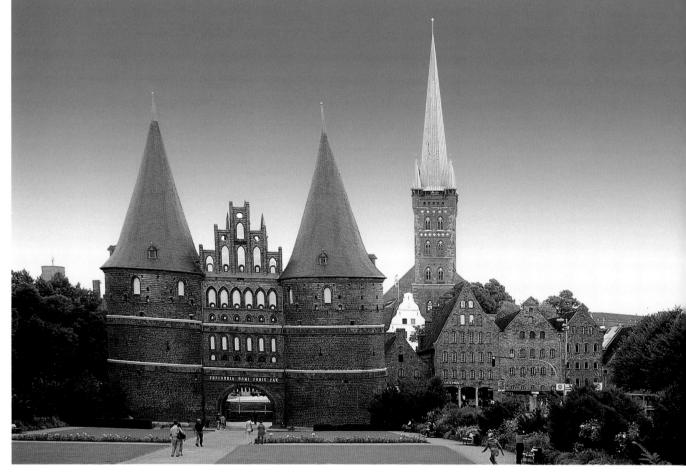

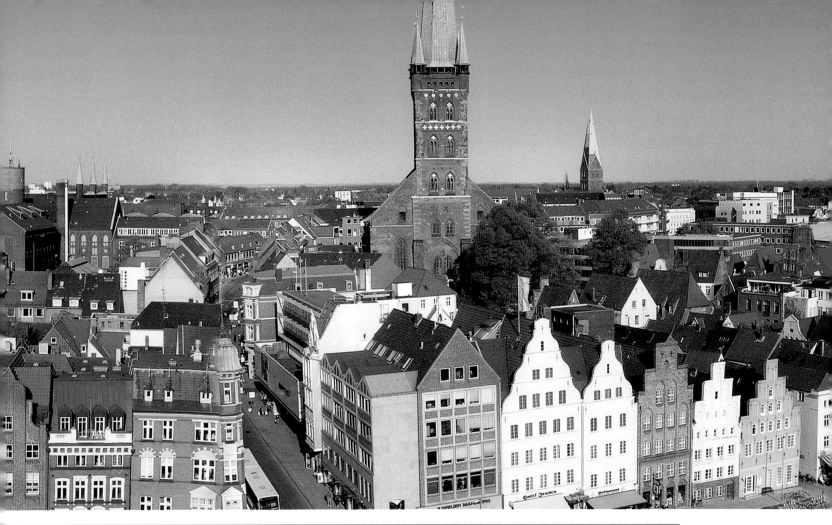

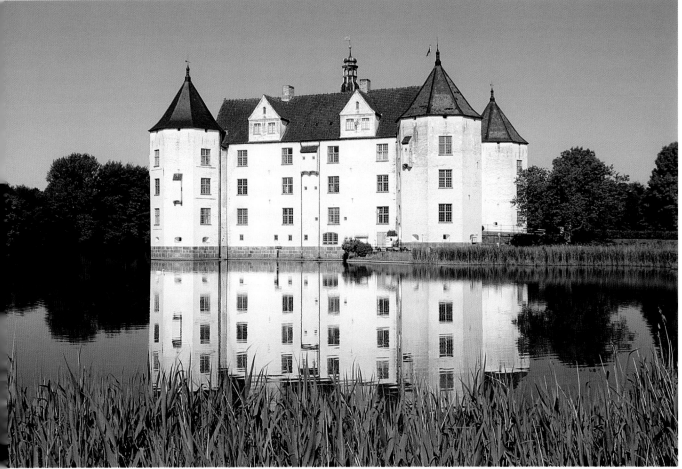

Left:
The moated castle of Glücksburg is one of the best Renaissance palaces in Northern Europe. It was the ancestral seat of the dukes of Glücksburg and even served the kings of Denmark as a royal residence for a while. The castle is one of the major sights of Schleswig-Holstein and is open to the public.

The huge statue of Roland on the market square is Bremen's city landmark. Since 1404 the stone figure has stood for civic pride and municipal freedom, closely safeguarding the independence of the Hanseatic city of Bremen.

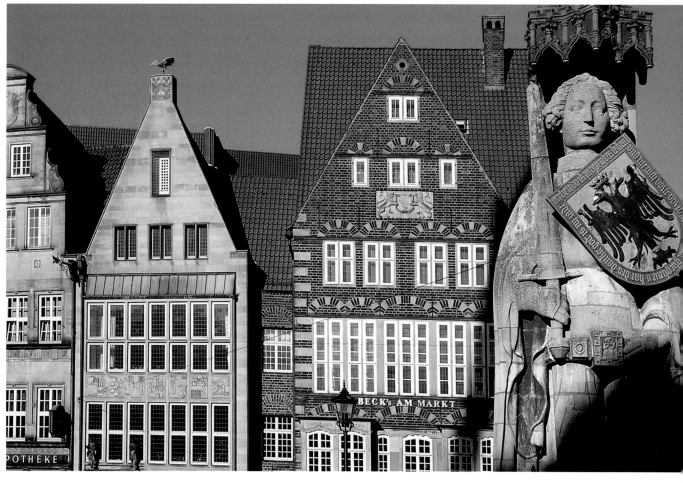

Right:
Böttcherstraße, one of the streets in Bremen's old town, is one of the city's major attractions. Most of the buildings were erected between 1922 and 1931 and are largely down to the enigmatic energies of one Ludwig Roselius, a Bremen coffee merchant. It was he who commissioned Bernhard Hoetger with the design of the street. The photo shows a relief above the entrance to Böttcherstraße which depicts Archangel Michael's battle with the dragon.

Far right:
This sculpture of the Bremen Town Band was created by Gerhard Marcks in 1953 and placed to the left of the Rathaus.

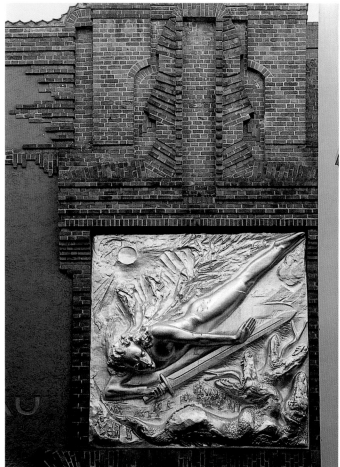

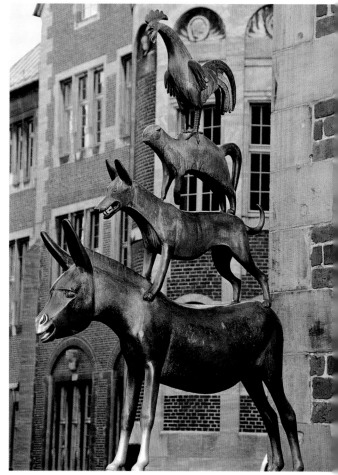

Leer in East Frisia was founded long before 800 and looks back on a turbulent history which is echoed in the splendid historic facades of the town. Not to be missed are the town hall from 1894, built in the style of the Dutch Renaissance, and the historic weigh house, with the museum harbour and many interesting marine craft flanking its quay.

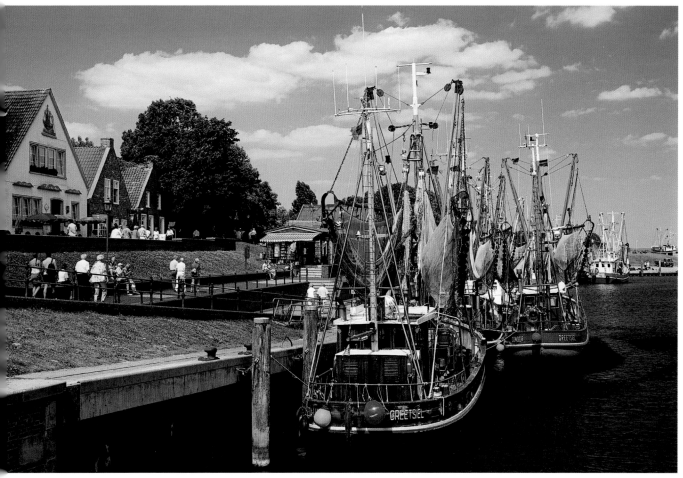

Greetsiel is a tiny harbour town on the Leybucht, a small cove on the west coast of East Frisia. Visitors flock to the historic old town and serene harbour with its shrimp cutters.

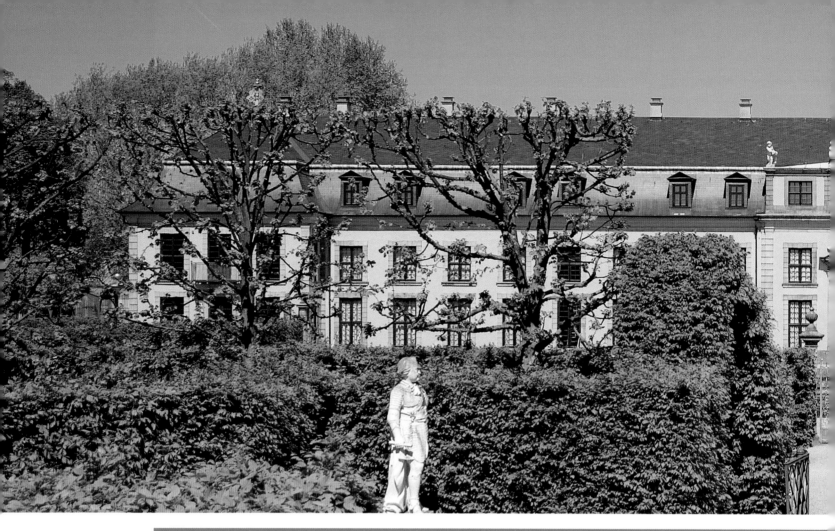

Above:
The Herrenhäuser Gärten in Hanover consist of the Großer Garten, the Berggarten and the Georgen- and Welfengarten. The Großer Garten, shown here, is one of Europe's best baroque gardens. It's also used as a backdrop for various musical and theatrical events staged here throughout the year, one of them being the Kleinkunstfestival or festival of cabaret.

Right:
The Neues Rathaus is Hanover's landmark. It was built in the Maschpark for 10 million marks and opened by none other than Kaiser Wilhelm II in 1913. The viewing platform is accessed by a lift which traces the arch of the dome, a construction unique throughout Europe.

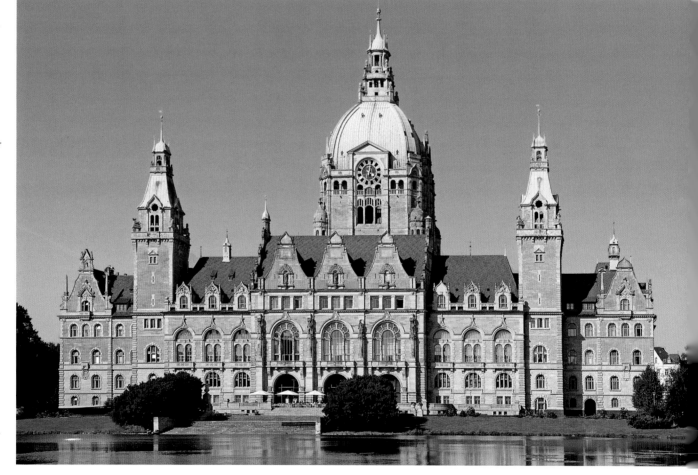

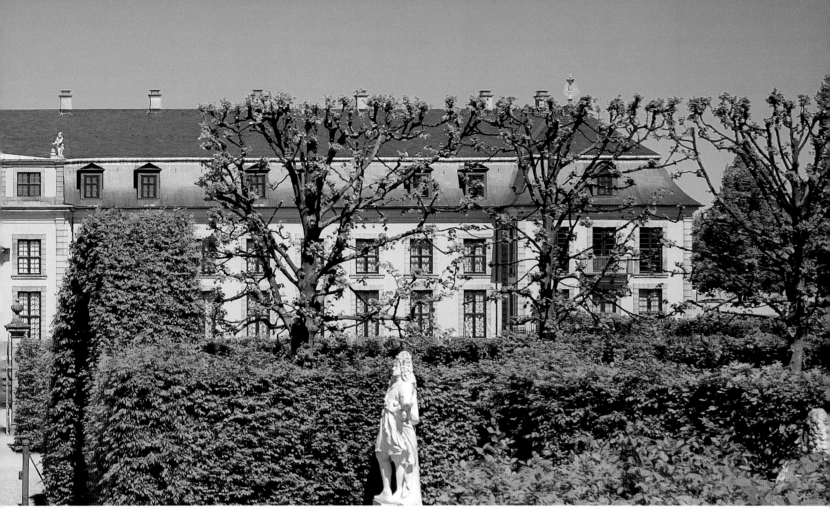

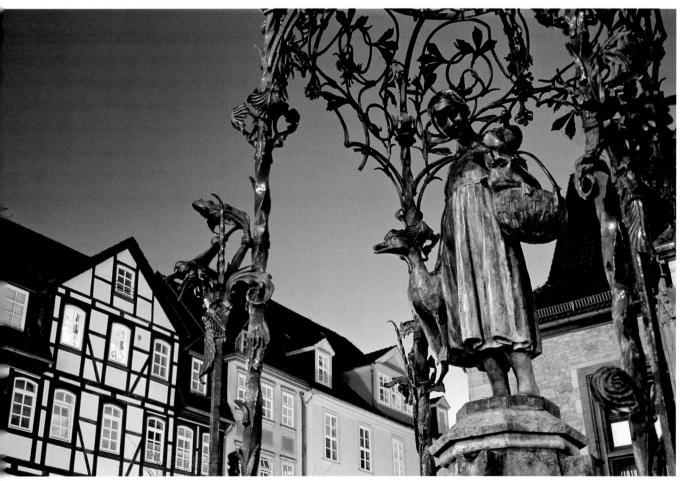

Left:
Göttingen is one of the most traditional university towns in Germany; over 40 Nobel Prize winners have studied or lectured here. Its local figurehead, the Gänselieselbrunnen, adorns the market square; the bronze figure is probably the most kissed girl in the country. Tradition has it that each new PhD student has to kiss Gänseliesel's feet.

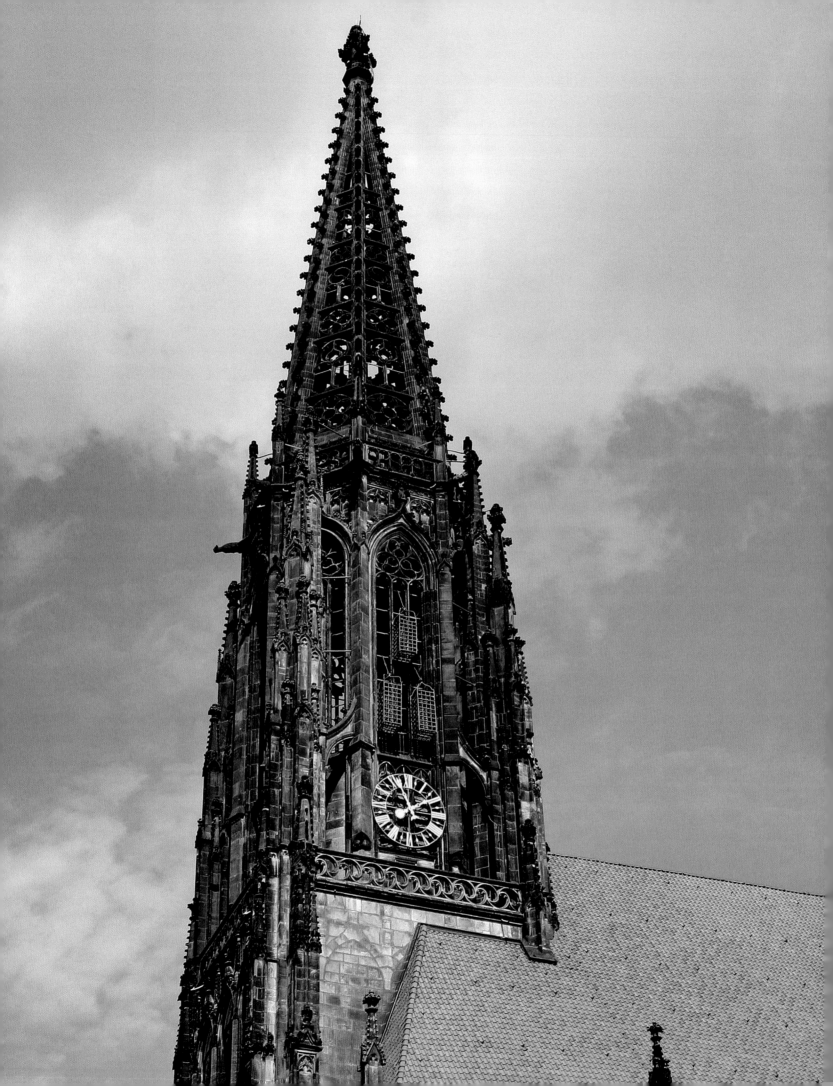

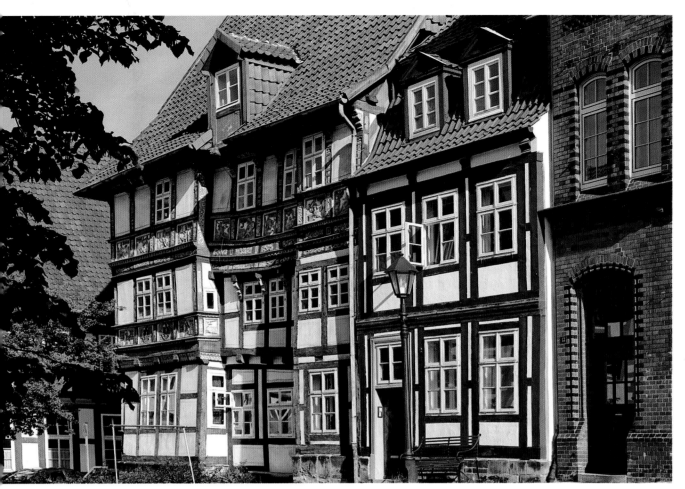

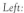

Left page:
The Lambertikirche was erected by Münster's merchant community in the year 1375 in answer to the mighty cathedral of St Paulus. The church rose to dubious fame for its iron cages, in which the bodies of executed Anabaptists were hung from the church steeple.

Left:
The old town of Hildesheim was one of the many casualties of World War II – yet a number of its half-timbered houses have survived, including the Wernersche Haus from 1606.

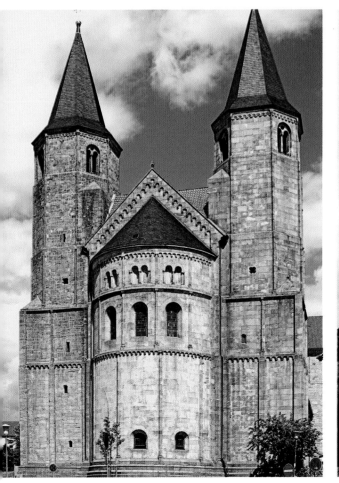

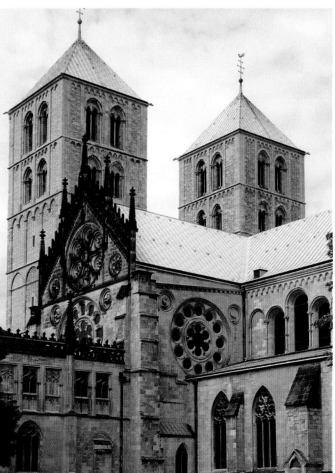

Far left:
After the cathedral and the Michaeliskirche the St Godehard basilica is Hildesheim's most prominent piece of sacred architecture. The Benedictine monastic church was constructed in high Romanesque during the 12th century to celebrate the canonisation of Benedictine abbot and later bishop of Hildesheim Godehard.

Left:
Dom St Paulus is Münster's number one ecclesiastical structure, erected on the site of an earlier place of worship from 805. The foundations for the present church date back to 1225; the entire building was completed in the space of just 40 years.

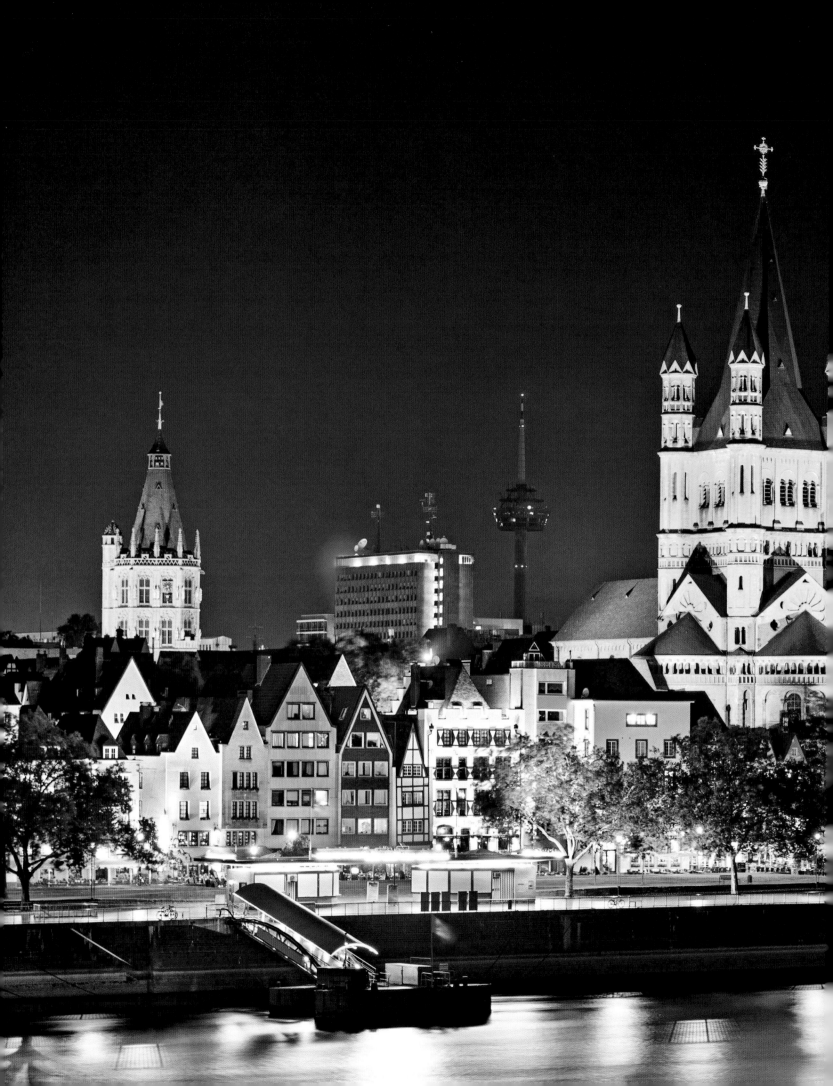

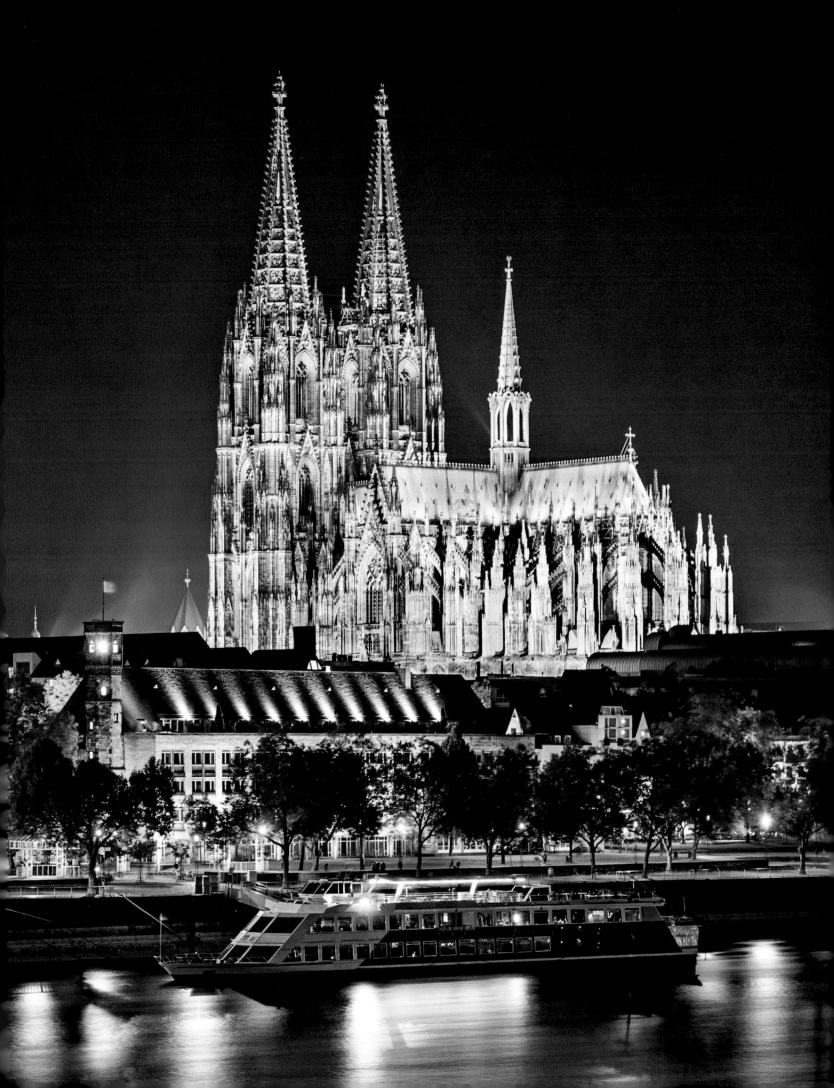

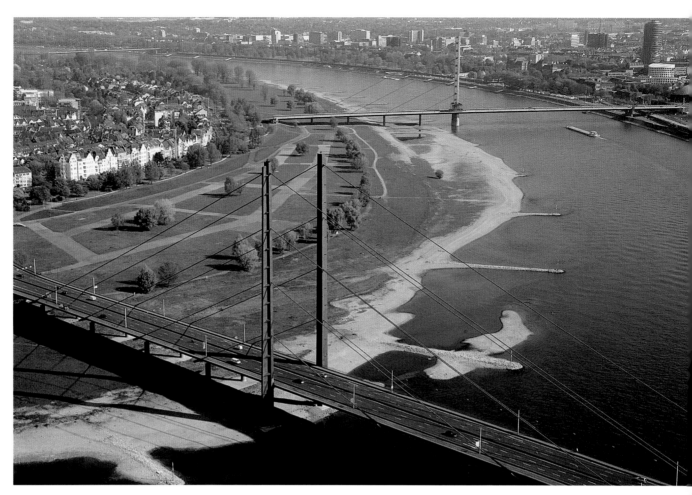

Right:
The Rhine divides the old town of Düsseldorf (right) and the suburb of Oberkassel, one of the city's most popular places to live. From the top of many of the town dwellings which escaped the Second World War there are grand views out over widespread fields, the Rhine and the skyline of Düsseldorf.

Page 34/35:
Even during the Middle Ages Cologne, the metropolis on the River Rhine, was one of the biggest and richest cities in the West. The river has shaped both its evolution and tested the patience of its inhabitants, who for centuries have had to cope with frequent flooding. Fischmarkt with its narrow houses on the river bank is one of the most scenic spots in Cologne. In the background are the twin Gothic spires of the cathedral (right) and the mighty edifice of Groß St Martin.

Right:
Schloss Benrath, just a few kilometres from the heart of Düsseldorf, was built in the style of the Rococo by Karl Theodor von der Pfalz from 1756 onwards. The palace is surrounded by lush parkland covering over 60 hectares (148 acres). The 470-metre (1,542-foot) long Spiegelweiher forms the main axis with the north flank of the palace. Benrath's proximity to the city makes it an ideal place for the people of Düsseldorf to come and unwind.

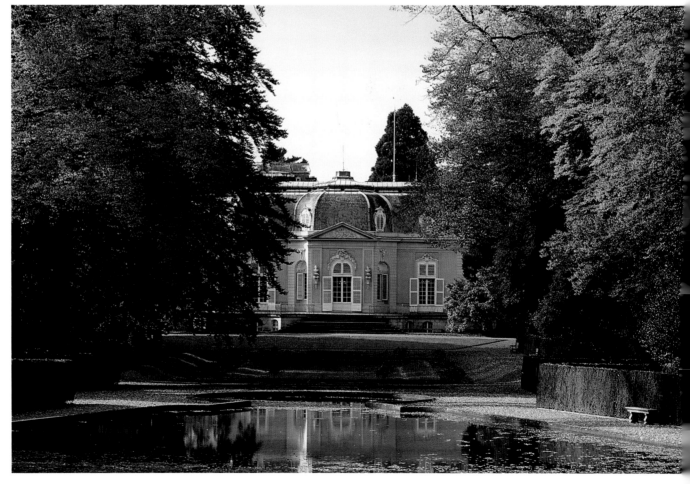

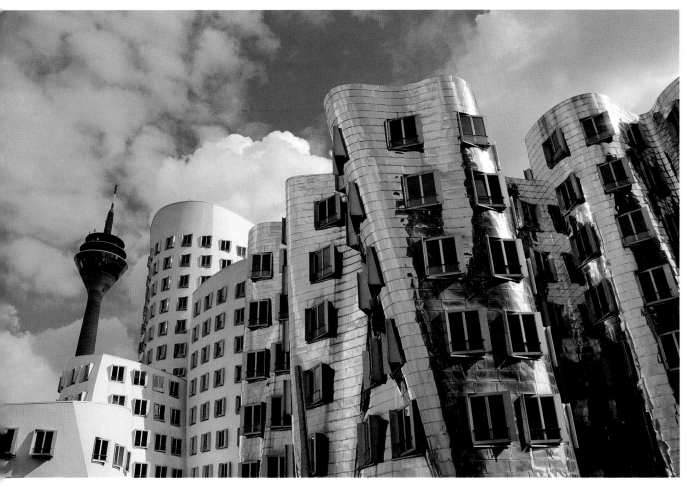

Between 1997 and 1999 Düsseldorf's harbour witnessed the erection of the futurist Neuer Zollhof complex by American architect Frank O Gehry. On completion it immediately became a mecca for fans of modern architecture.

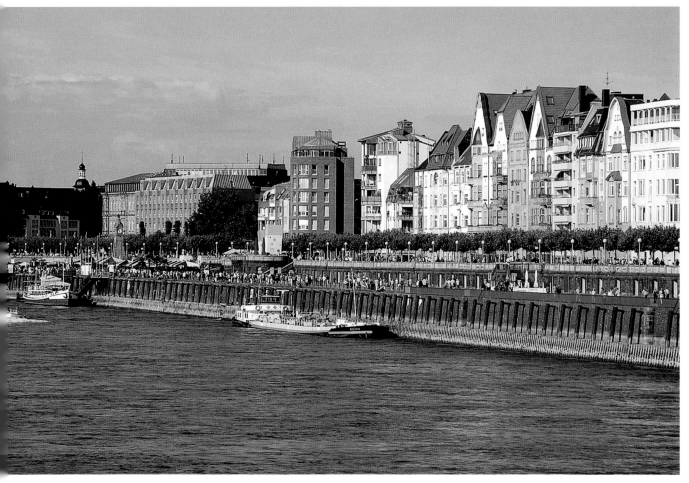

Besides the Kö Düsseldorf's Rhine promenade is one of the most popular esplanades in the city. Walking straight on past the Rathaus (left) you come to the old town whose undoubtedly most famous assets are its many Altbier pubs, the best known of which are Uerige, Brauerei im Füchschen and Brauerei Schumacher.

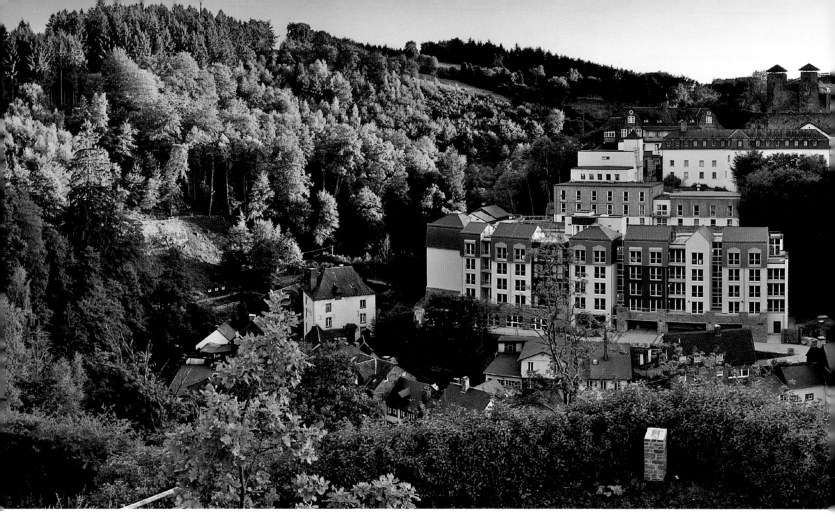

Above:
Monschau lies tucked in between the elevations of the Hohes Venn (Hautes-Vagnes) national park in the Eifel and is famous for its narrow winding streets and old half-timbered houses. Monschau was first mentioned in 1198 and its castle erected during the 13th century. From the 16th century onwards the town lived off the textiles industry; the last spinning mill closed down here in 1982.

Right:
The Harz Mountains are famous for their wonderful scenery. The Bodetal in particular, made a nature reserve in 1937 and shown here near Treseburg, is packed with interesting plants and animals typical of the region.

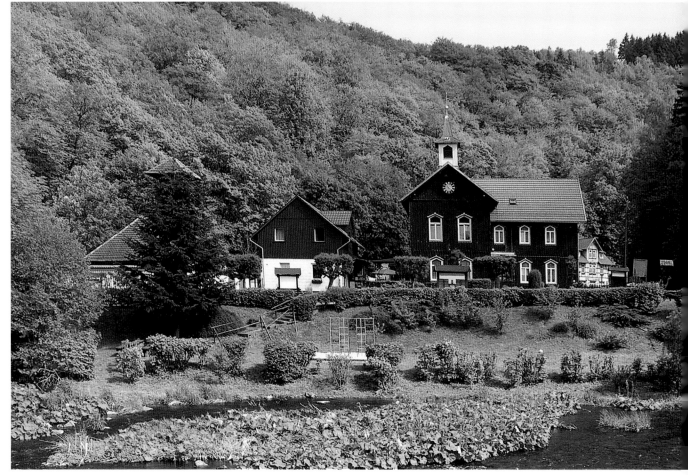

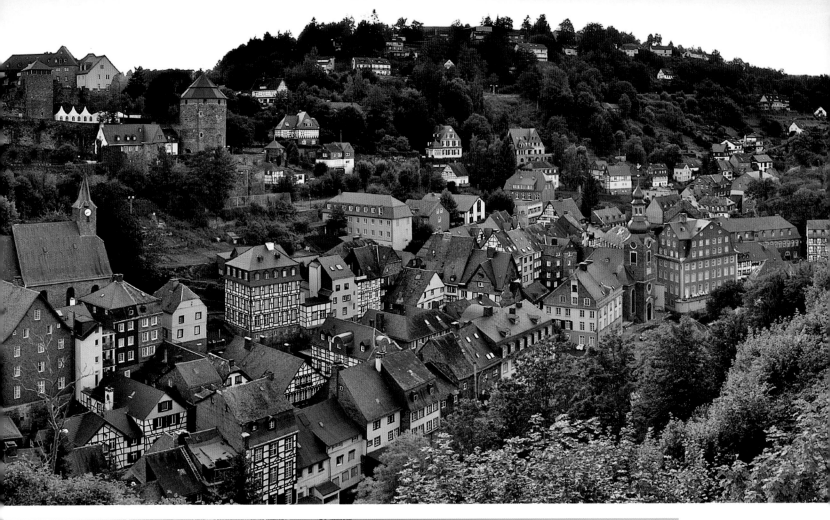

Left:
The Efiel Hills are famous for their Maare, old volcanic craters which have filled with water. There are many sagas told about the Weinfelder Maar, also known as the "lake of death"; one hard-hearted countess is said to have sunk into the ground here, complete with her castle, with the lake now marking the spot.

Page 40/41:
Freudenberg is an old mining town near Siegen. The ensemble of half-timbered buildings in the Alter Flecken quarter is absolutely unique.

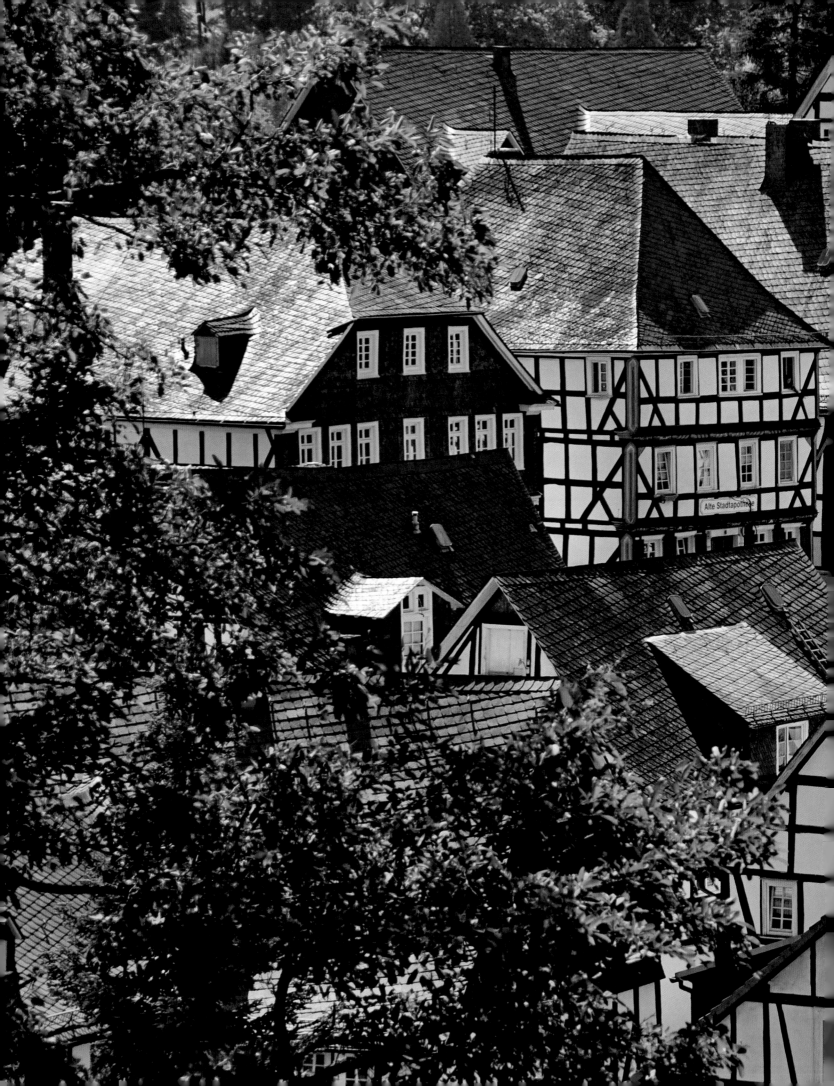

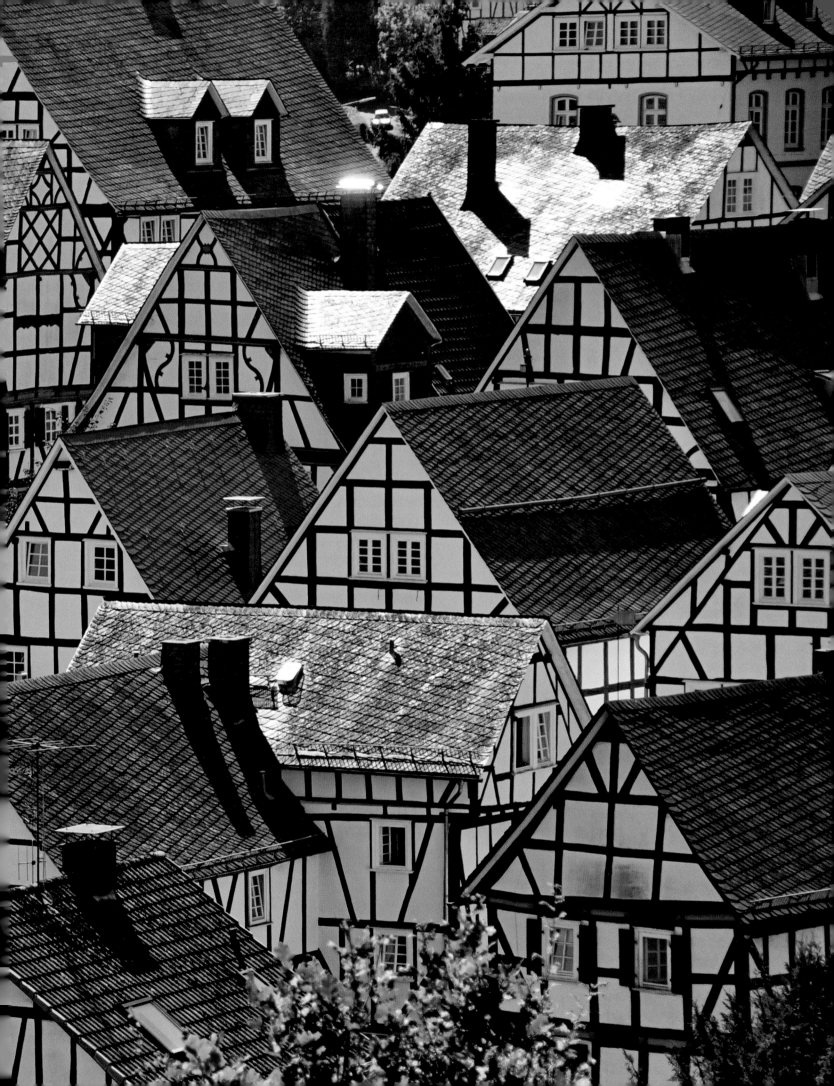

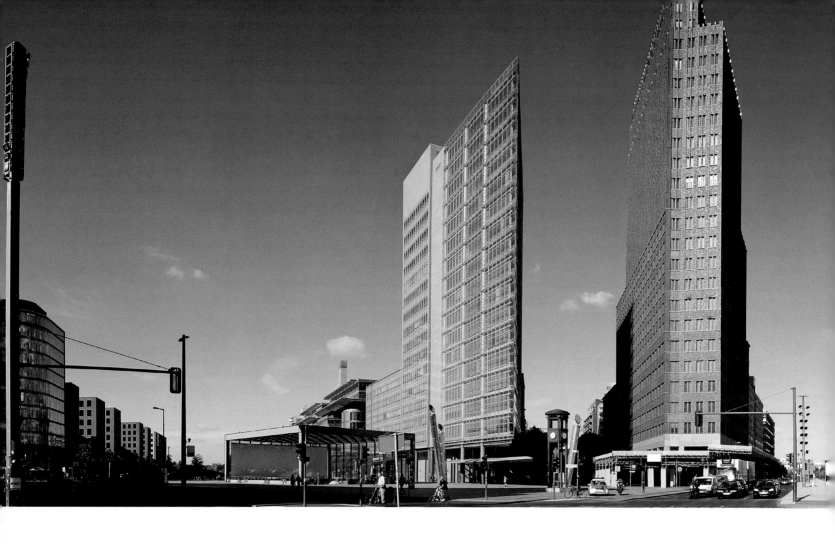

GERMANY'S EAST – FROM THE BALTIC TO THE ERZGEBIRGE

The coast of Mecklenburg-West Pomerania is 1,470 kilometres (913 miles) long and has no less than 794 offshore islands, Rügen being the best known. In 1818 artist Caspar David Friedrich, born in Greifswald in 1774, captured its gleaming chalk white cliffs in a painting which was to become famous all over the world. The quiet spots where the Romantics once sat and reflected on their surroundings and their emotions can still be found.

Brandenburg also has a fantastic watery landscape a glorious green paradise in the Spree Forest. Much of t rest of it is dry sand and expansive forest, perhaps m eloquently described by Theodor Fontane (1819–189 The beating heart of Brandenburg is definitely the G man capital of Berlin which does itself proud. The n government quarter with its domed Reichstag and dip matic strongholds representing all corners of the glo have again made Berlin the buzzing capital it once w Such show is not typical of Saxony-Anhalt, Brande burg's neighbour, which instead concentrates on t more peaceful disciplines of art and art history. T twelve world-famous statues from the workshop of t Master of Naumburg in the west choir of Naumbu Cathedral are among the most significant sculptures the Middle Ages.

Most of the edifices in Saxony and Dresden 'only' da back to the reign of Augustus the Strong whose entl siasm for art and architecture helped earn Dresden t epithet of "the Florence on the Elbe".

And what Augustus was to Saxony, Johann Wolfga von Goethe was to literature in Weimar in Thuring At the end of the 18th and beginning of the 19th centur the little town on the River Ilm was the intellect centre of Germany.

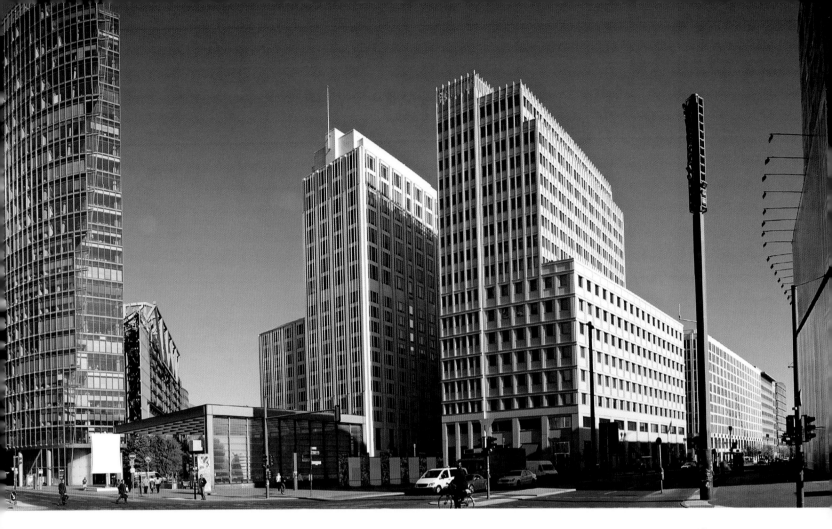

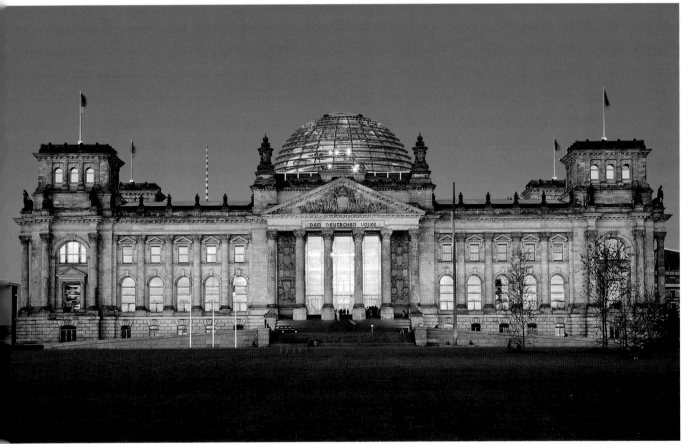

Right:
The television tower on Alexanderplatz, 365 meters (ca. 1,200 feet) high and complete with a revolving restaurant, dominates the Berlin skyline. Other landmarks on the infamous square are the monument to Marx Engels (centre) and the Rotes Rathaus (right).

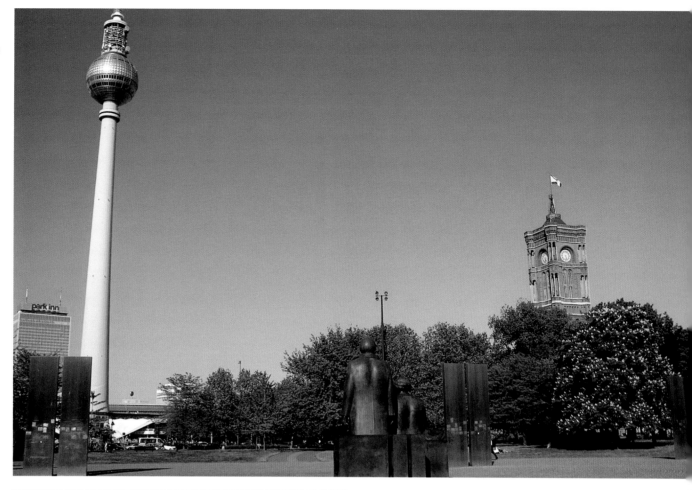

Right:
The Siegessäule or Victory Column on the Straße des 17. Juni marks the middle of Tiergarten, Berlin's largest park. The pillar originally stood outside the Reichstag and was moved here in 1938. If you climb the 285 steps to the top, you are rewarded with splendid vistas of Berlin.

Top far right:
While the Wall still stood the Oberbaumbrücke in Berlin acted as a border crossing. Following the Reunification of Germany the Gothic brick was revamped by Santiago Calatrava.

Bottom far right:
Kurfürstendamm in Berlin, with the memorial church to Kaiser Wilhelm in the background, was once a bridleway leading from Berlin to the hunting lodge at Grunewald.

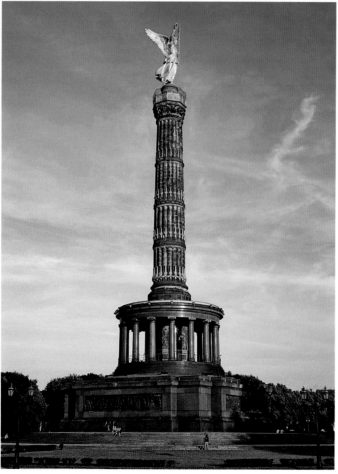

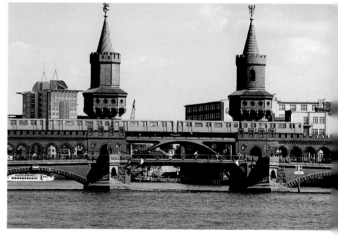

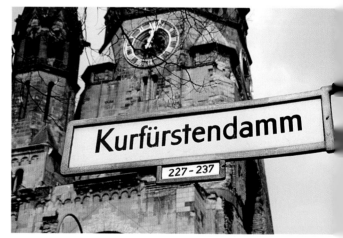

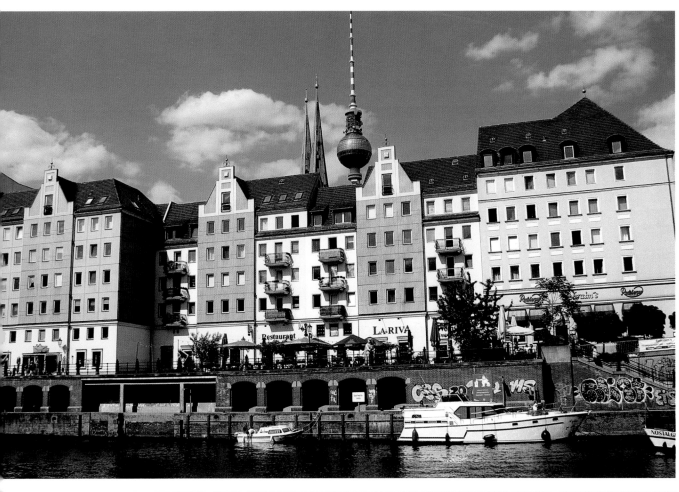

Berlin's Nikolaiviertel on the River Spree was rebuilt in 1987 to celebrate 750 years of Berlin. It was intended to recreate the winding streets of Old Berlin, with plenty of shops and restaurants enticing you to take a leisurely stroll.

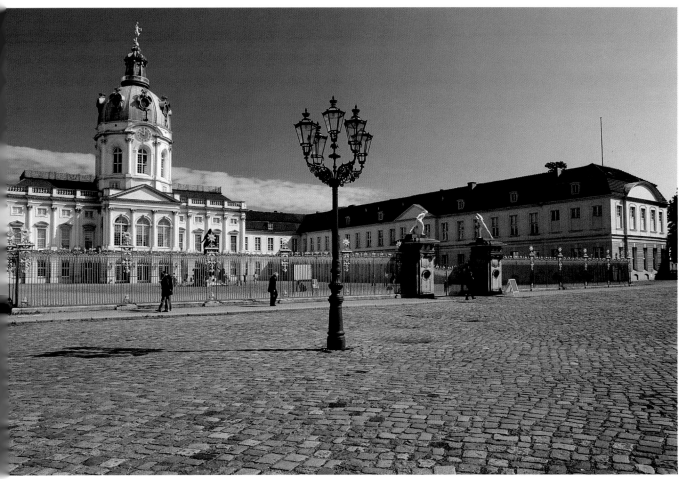

Schloss Charlottenburg in Berlin was originally a summer residence for the electors of Brandenburg but soon became synonymous with absolutist power. The full length of the building runs to over 500 meters (1,640 feet).

With its delightful array of palaces and gardens Sanssouci in Potsdam is one of the best historic sites of this kind in Germany. The absolute highlight of the complex is the vineyard terrace leading up to Schloss Sanssouci. The gardens were designed by Prussia's gardener of renown Peter Josef Lenné.

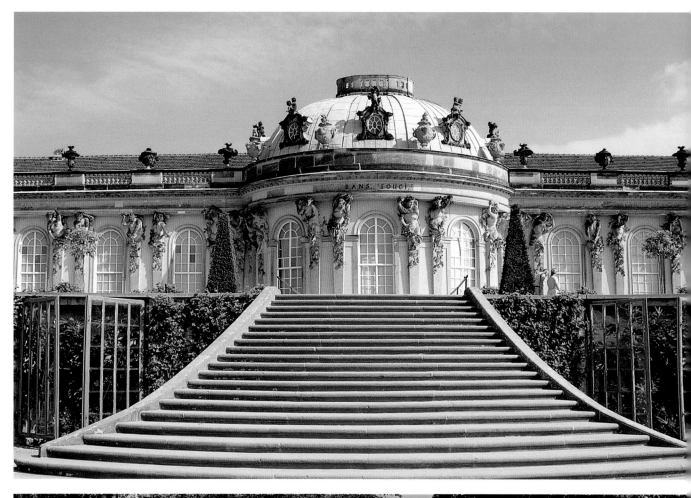

One travel guide from 1900 pays effusive homage to the palace: "The park at Sanssouci is rightly appraised as being tremendous by all who come here. Nature, art and history create a whole in kaleidoscopic composition which in its harmonious conclusion agreeably touches each visitor, allowing them to depart with a sense of great satisfaction." In the centre of the photo is "Old Fritz" or Frederick II ("the Great") of Prussia.

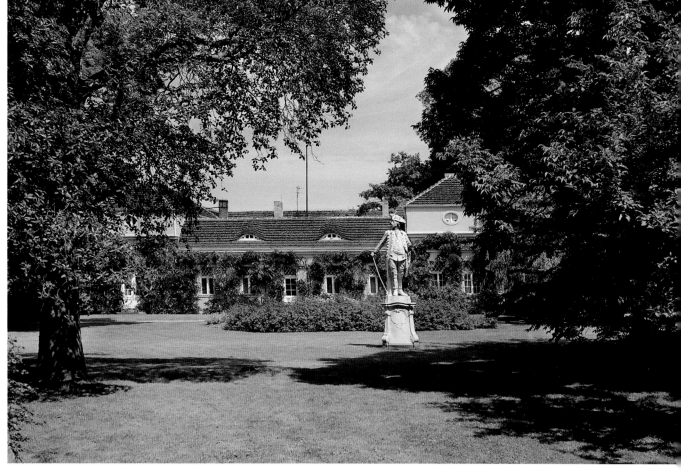

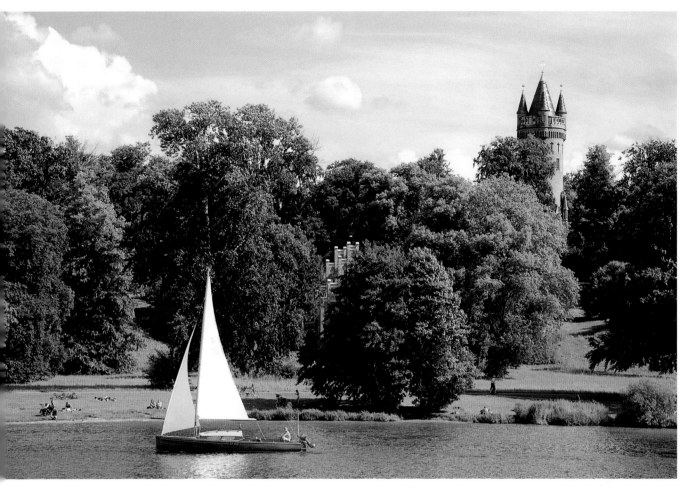

Inspired by a trip to England, architect Schinkel was prompted to build Schloss Babelsberg in mock Tudor from 1833–1849, complete with bay windows and ramparts. Here the Flatowturm.

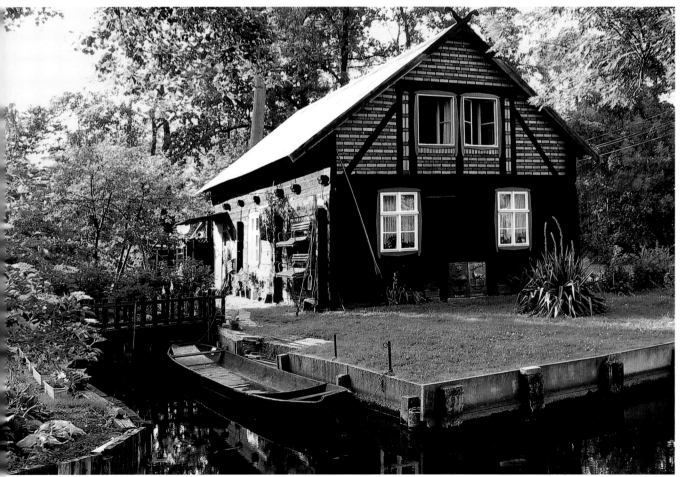

In the Spree Forest with its countless canals and little rivers. In his Travels through the March of Brandenburg Theodor Fontane noted, "We have reached Lehde, the first village in the Spree Forest. It is a pocket version of the lagoon city, a Venice as it might have been 1,500 years ago, when the first fishing families sought refuge on its swamp islands. There is nothing more delightful to the eye than Lehde, which has as many islands as it has houses."

One of the much admired sights on Rügen is the new pier at Sellin, based on the older version which was destroyed by ice floes in 1941.

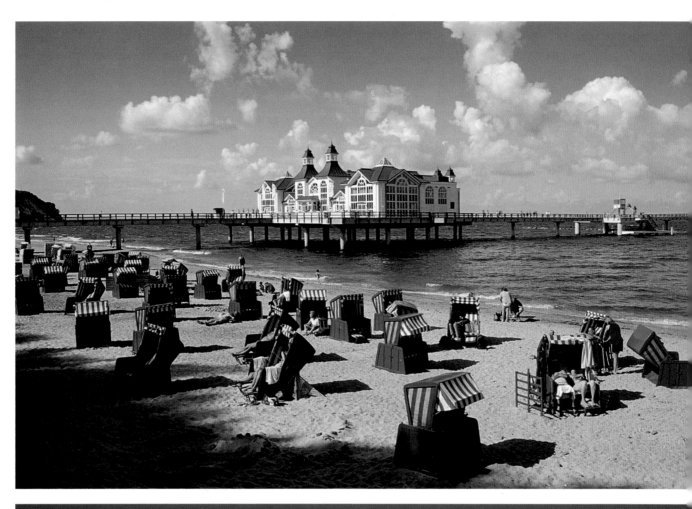

Fishing boats on the beach at Baabe. In 1905 the little town caused an absolute scandal by allowing men and women to bathe together on Rügen for the first time. With its wonderful sandy beach, Baabe is now a great place to come and spend a quiet holiday by the sea.

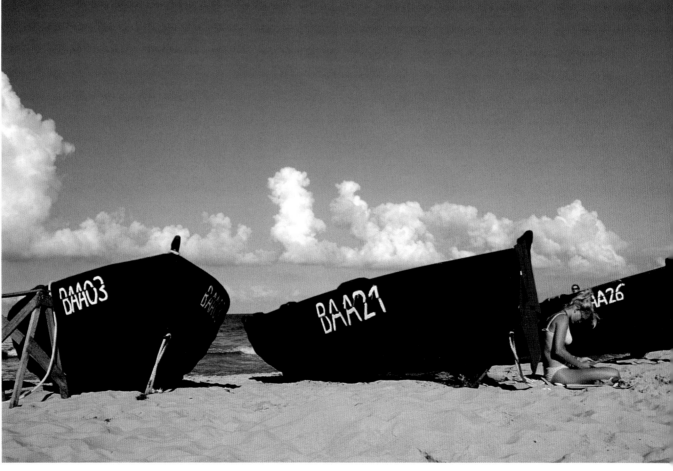

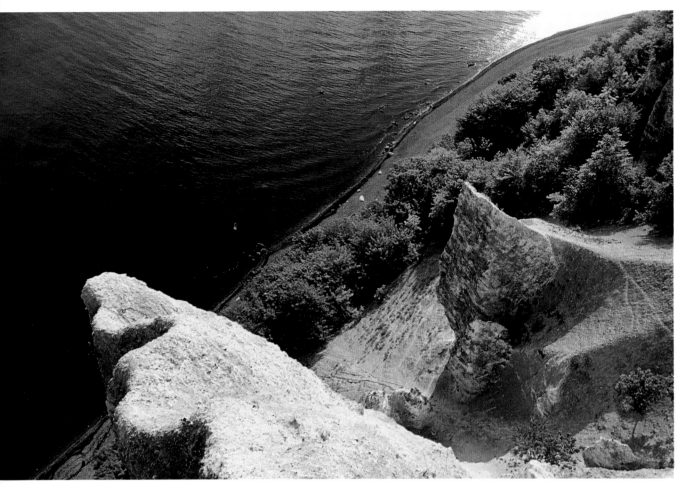

Together with the Königs-stuhl the Wissower Klinken are said to be the biggest and most magnificent chalk cliffs on the island of Rügen. The name is reminiscent of the period under Swedish rule, which ended in 1815, and is derived from the word Klinter which means "rocky crag".

In the days of yore nearly all of the fisherman's huts on the Baltic had thatched roofs like this one in Born on the Darß coast. The natural materials are still easy to come by and thatching is now experiencing something of a renaissance – for those who can afford it…

49

The Alter Markt in Stralsund boasts several gems of the German brick Gothic period. The Rathaus with its showy 14th-century facade is heralded as the most splendid in North Germany. The Nikolaikirche next door to it was begun in 1270 and finished over 70 years later.

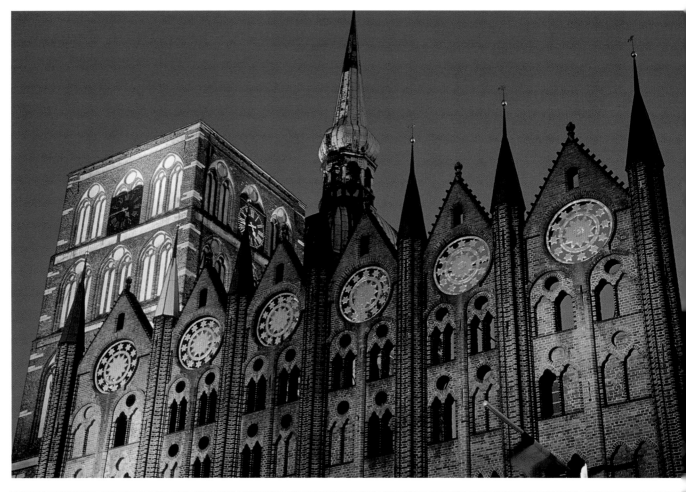

Shrouded in eerie fog Schloss Schwerin looks like something out of a fairytale. During the 19th century the palace was built on an island in the Schweriner See for the dukes of Mecklenburg. The Landtag or state parliament of Mecklenburg-West Pomerania is now resident here.

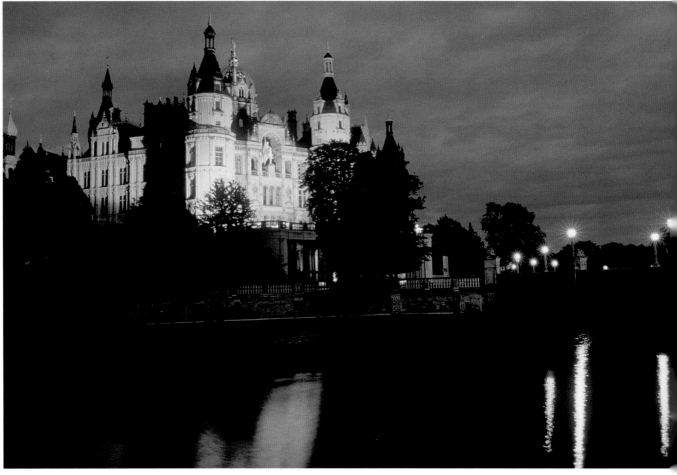

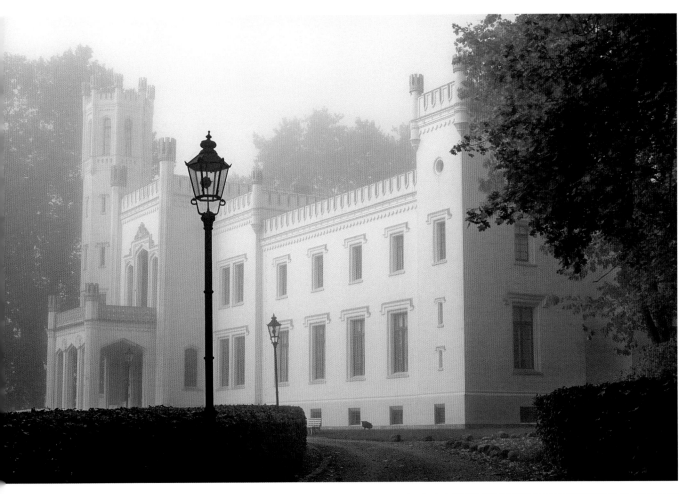

In the early morning light, with the mist still hugging the ground, Schloss Kittendorf seems like a mirage, its contours hidden by the grey hues of dawn. The palace was built under Hans Friedrich von Oertzen over 150 years ago in English mock Tudor, the style impressed upon the site by architect Friedrich Hitzig. Landscaping wizard Peter Joseph Lenné was also commissioned to work his particular form of magic on the surrounding gardens.

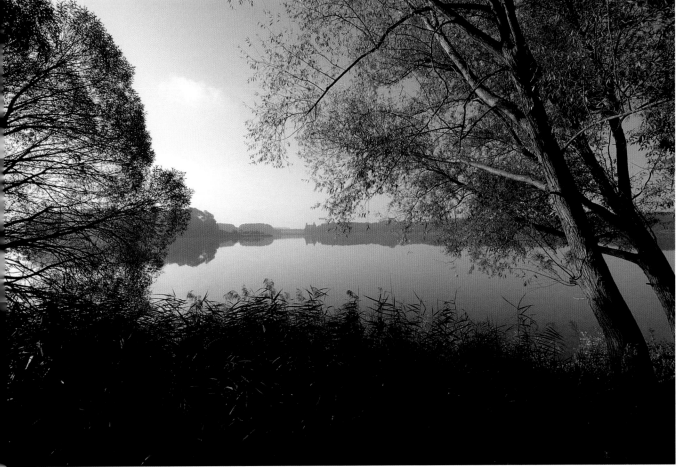

Ivenacker See not far from Stavenhagen. With a twist of irony both critical and affectionate local author Fritz Reuter often wrote about his native landscape and fellow inhabitants, claiming "[It is] the best thing I have known on this earth".

Page 52/53:
Dresden's famous panorama, one of the reasons for its epithet of "Florence on the Elbe". Other treasures include (from left to right): the Schloss, Hofkirche, Semperoper and Augustusbrücke.

51

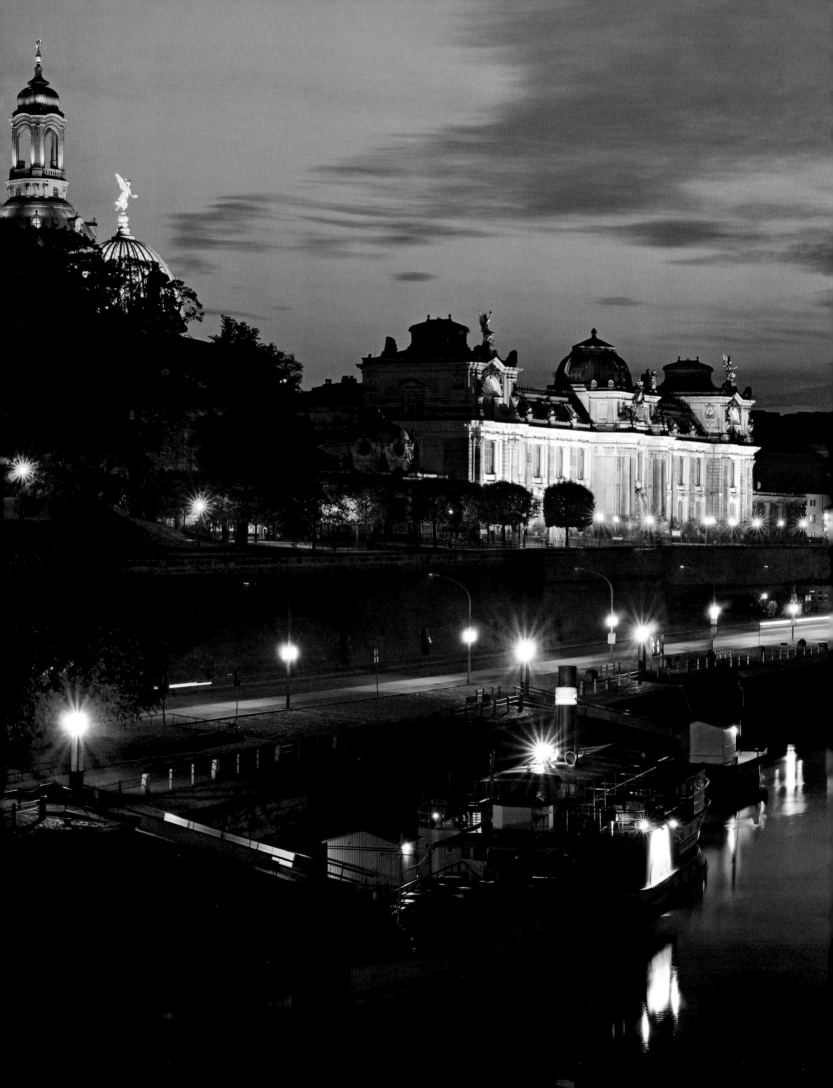

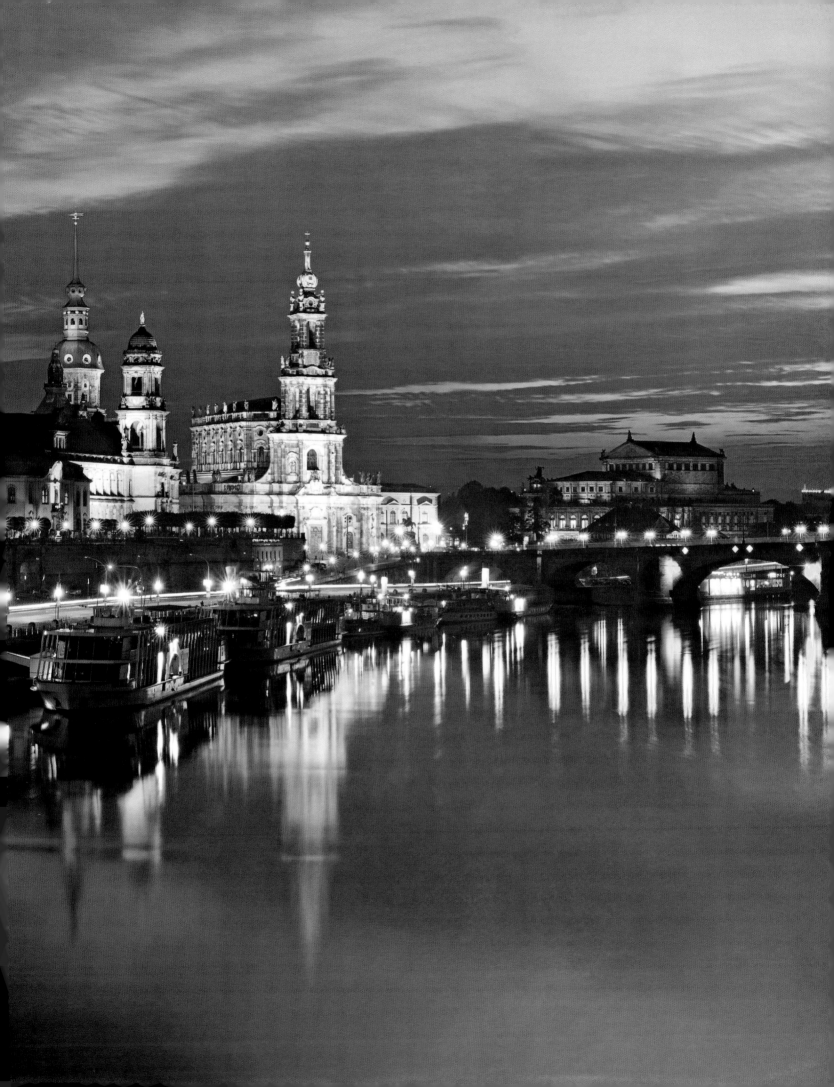

Jagdschloss Moritzburg is 18 kilometres (11 miles) from Dresden and in its present form dates back to Augustus the Strong. Dresden's ruler had the hunting lodge converted into a baroque palace by Pöppelmann between 1723 and 1736.

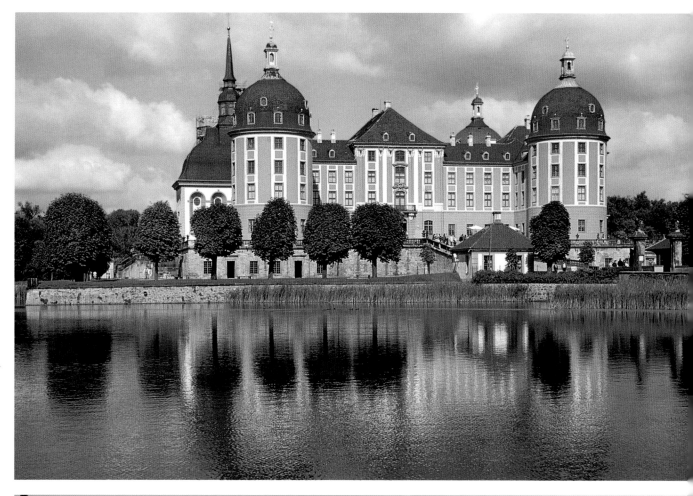

Right page:
The Frauenkirche is one of Dresden's most distinctive buildings. Completely destroyed in 1945, the ruins were left standing in the heart of town as a memorial. On the fall of the Iron Curtain private campaigning brought in donations from all over the world and rebuilding began. The church was reopened in 2006 in the course of Dresden's 800th anniversary. The blackened masonry has been rescued from the rubble of the old Frauenkirche.

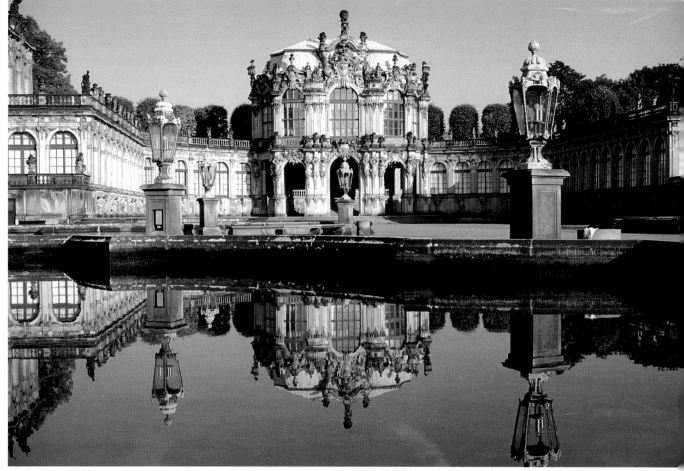

The Dresden Zwinger, created by architect Matthäus Pöppelmann and sculptor Balthasar Permoser, is the city's most famous construction and unique to the baroque period. The building was designed for Augustus the Strong not as a residence but purely for representation.

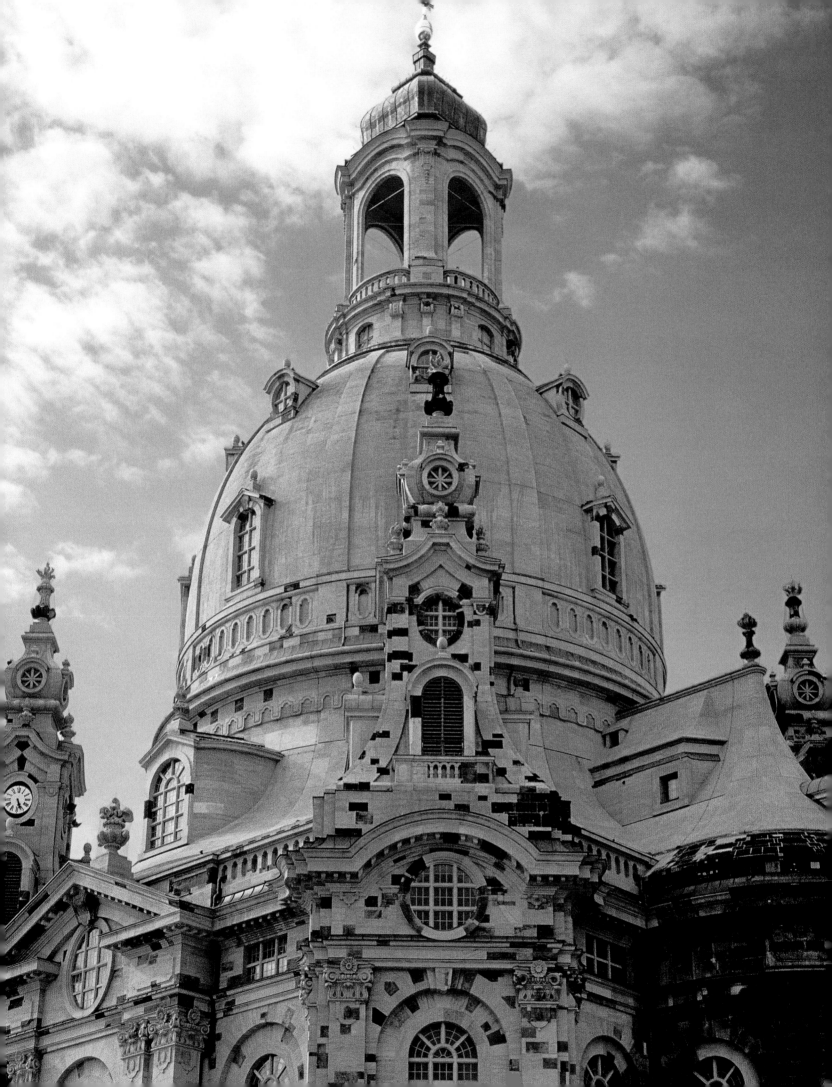

On Naschmarkt in Leipzig outside the old stock exchange there is a famous statue of Goethe which commemorates his student days in the city. It shows an enigmatic young man ready to hotfoot it to his nearby regular haunt, Auerbachs Keller. The two medallions on the base depict his flame Käthchen Schönkopf and his confidante Friederike Oeser whose father gave Goethe painting lessons. On the left is the Altes Rathaus from 1557 and on the right the stock exchange from 1678.

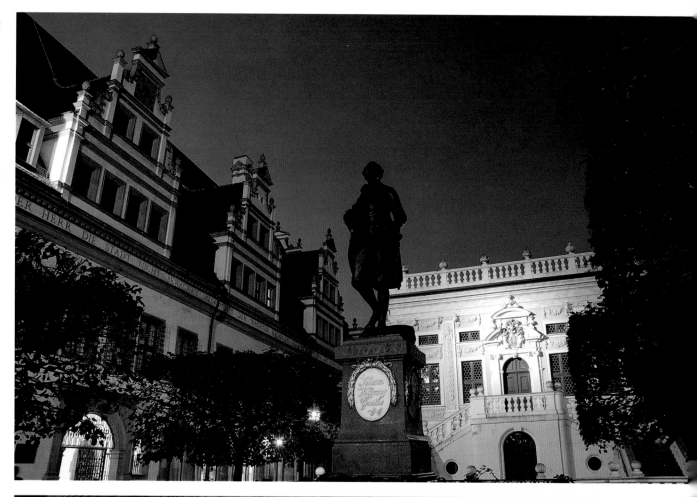

Auerbachs Keller bang in the middle of the Mädler-Passage has been serving wine since 1525. The memory of Faust and Goethe is sustained with such enthusiasm here that the pub has become both a gastronomic and cultural highlight of historic Leipzig.

The courtyard exits onto a square featuring a fountain of Lipsia between Barfußgasse and Kleine Fleischergasse, now part of Leipzig's humming pub scene. If you fancy an authentic night out on the town, just ask for directions to "Drallewatsch". Cheers!

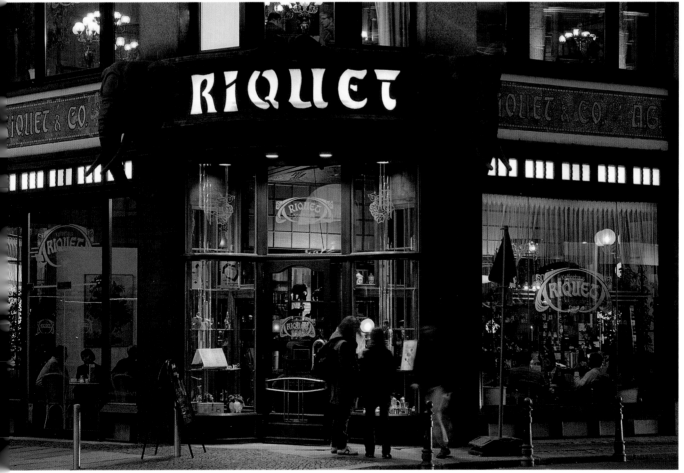

The Riquet-Haus from 1908/09 presents Leipzig as an intersection of north and south, of Wild West and Far East. The Huguenot trading dynasty once ensconced here used to do business with China, Japan and India, a fact mirrored by the exotic design of the facade.

57

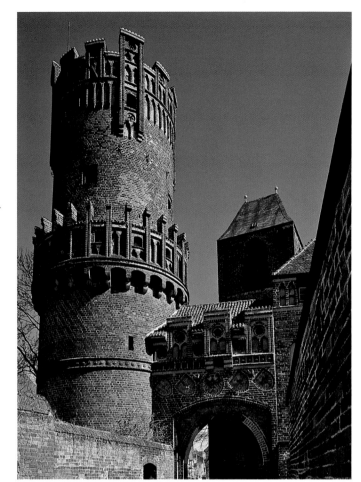

Right:
Tangermünde takes its name from its location at the confluence of the Tanger and Elbe rivers. The town is famous for its old centre with its many well-preserved half-timbered and brick buildings. Here the Neustädter Tor.

Far right:
Stendal in Saxony-Anhalt. The old Hanseatic town boasts many relics of the Gothic brick period: here the town hall with its statue of Roland and the mighty spires of the Marienkirche behind it.

Merseburg an der Saale is one of the oldest towns in Central Germany. First mentioned in the 9th century, it soon became a major religious centre. The foundations for the first cathedral in the bishopric of Merseburg were laid in 1015 by Bishop Thietmar von Merseburg (photo left).

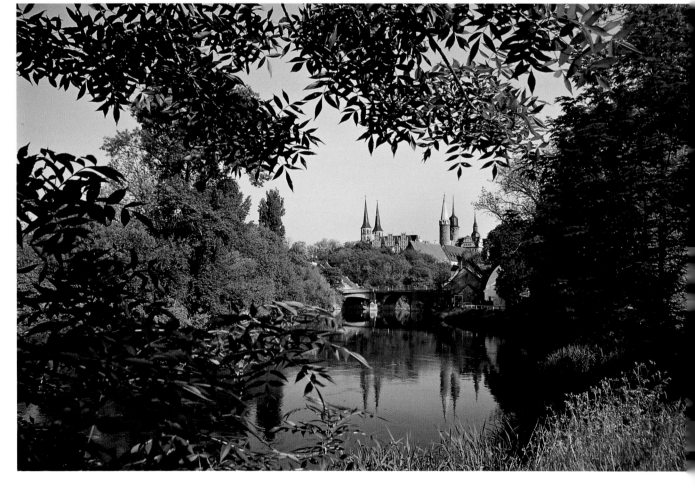

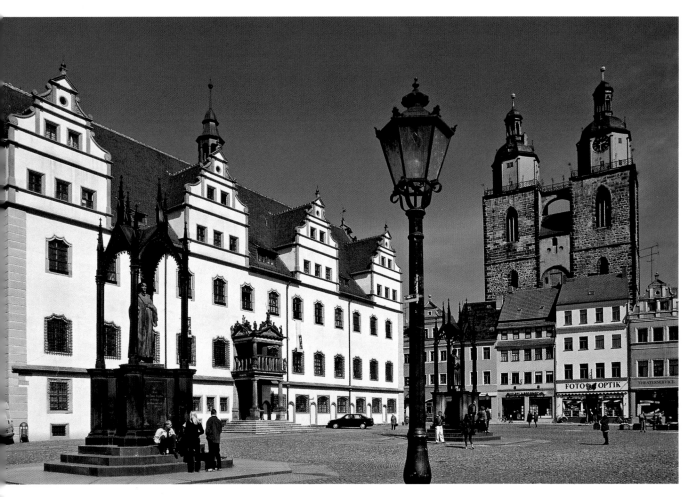

The parish church of St Marien in Wittenberg was where reformer Martin Luther once nurtured his revolutionary ideas. In 1821 a monument was erected in his honour on the market place with its magnificent Renaissance houses.

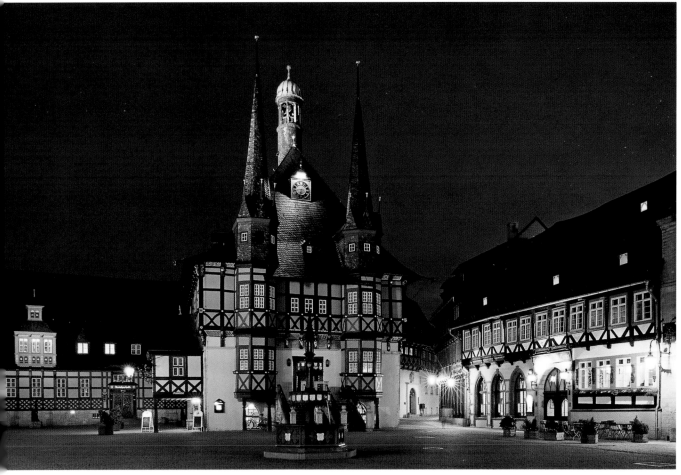

The focal point of Wernigerode is its medieval Rathaus on the market square. The beams bear an interesting assortment of carved figures – from saints to fools to travelling entertainers.

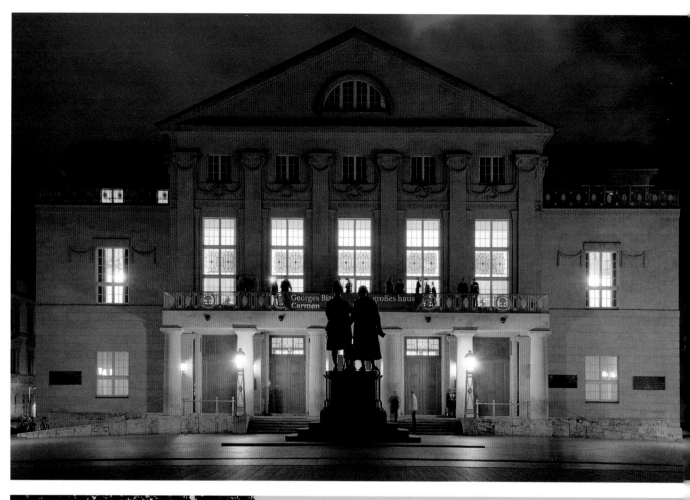

Reduced to its facade and outer walls by the bombing of February 9, 1945, the present Nationaltheater in Weimar reopened its doors in 1948 with a performance of Goethe's Faust. The statue of Goethe and Schiller outside it (1857) is the work of Ernst Rietschel.

Schiller lived in his house on the Esplanade (now Schillerstrasse 12) for just three years, from 1802 until his death in 1805. Here he penned his final works, among them *Die Braut von Messina* (The Bride of Messina) and *Wilhelm Tell* (William Tell). Goethe's house on Frauenplan is just around the corner.

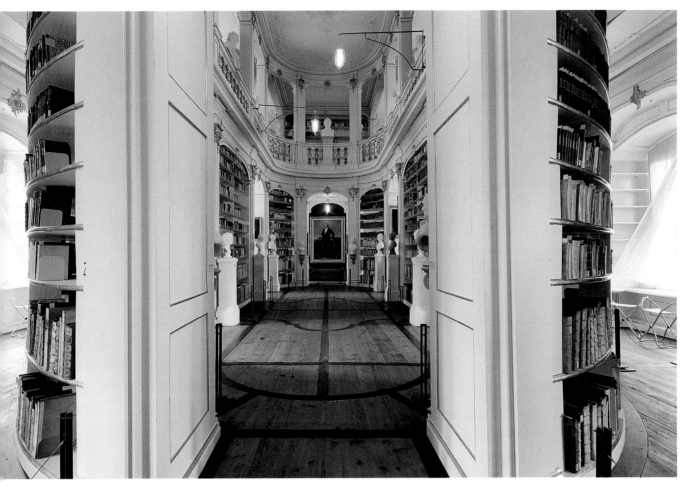

The Herzogin Anna
Amalia Bibliothek is one
of the largest and most
important libraries in
Germany. The Grünes
Schloss built in 1562–65
was at first the abode of
one of the duke's brothers;
in 1761–66 Duchess
Anna Amalia had it con-
verted into a library. It
was also the duchess who
made its contents accessi-
ble to the general public.
Goethe, who was charged
with its supervision in 1797,
greatly helped extend the
precious stock.

The Gartenhaus in the
park on the River Ilm in
Weimar was where Johann
Wolfgang von Goethe
once lived and worked.
Several major opuses,
among them Egmont and
Torquato Tasso, were
written here between 1776
and 1782. The building's
limited space and poet's
growing social status soon
caused him to move to
more commodious premises
on Frauenplan. The
Gartenhaus remained his
favourite abode, however.

No less than three castles sprawl across the plateau above the River Saale in Dornburg in Thuringia. The Renaissance palace, called Strohmann'sches Schlösschen or Goethe-Schloss, is the second oldest and was built in the 16th century. Goethe was a guest here from September 7 to 11, 1828.

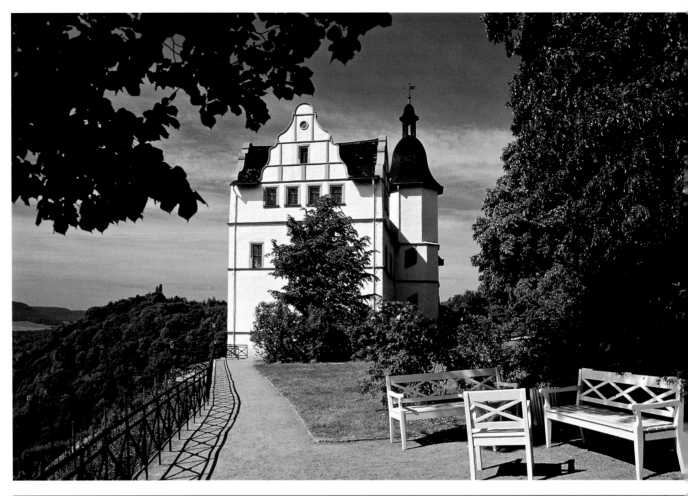

In Gotha in Thuringia the Rathaus forms the centre-piece of the Hauptmarkt. The foundations of the prestigious Renaissance town hall were laid in 1567. In the past Gotha has been something of a rival to Weimar; where Weimar was the cultural centre of the region, Gotha was its scientific counterpoint.

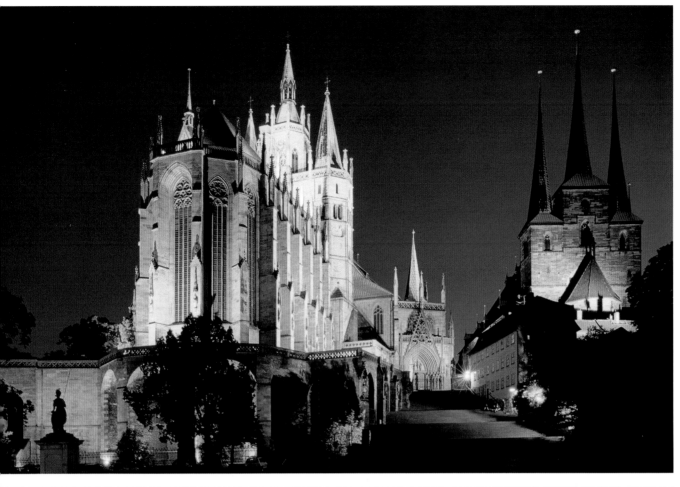

Erfurt is the state capital of Thuringia and its undisputed landmark is the magnificent ensemble of the cathedral (left) and Severikirche (right) on Domplatz, unique in Europe. The churches are built on a natural mound, with over 70 steps leading up to the top. The cathedral bell, Gloriosa (1497), is the largest free-swinging medieval bell in Europe.

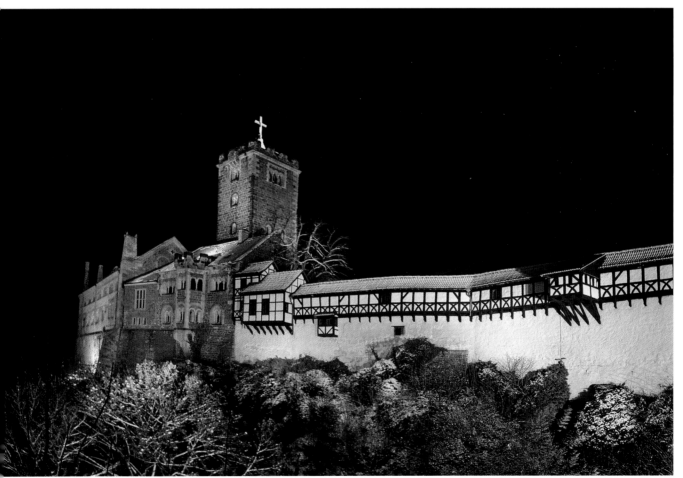

The Wartburg near Eisenach in Thuringia was founded by Thuringian count Ludwig der Springer in c. 1067 and made a UNESCO World Heritage Site in 1999. The castle is inextricably linked to the history of Germany. Elisabeth of Thuringia, later made a saint, lived here from 1211 to 1227; from 1521 to 1522 Martin Luther hid here and Goethe visited the castle often, the first occasion being in 1777. The Wartburgfest of 1817 and 1848 even heralded political change.

Germany's south – from the Rhine to the Alps

The route to southern Germany is mapped out by the River Rhine and its tributaries. South of Bonn it snakes through spectacular scenery, gliding beneath steep vineyards straddled by once mighty castles. The fortresses continue into the windswept hills of the Eifel and the Palatinate Forest; nearby the River Moselle has created a fascinating cultural landscape. The River Main dominates the southern reaches of Hesse, passing through Frankfurt, the financial capi of Germany and Europe. The city still effuses a frier ly charm, encapsulated in its many cider taverns the district of Sachsenhausen, for example. Frankf is also a centre of the arts and publishing, which c maxes in the annual international book fair, t largest in the world, set against the skyscrapers Mainhattan.

The riverine scenery continues almost uninterrup on into Baden-Württemberg. This is the warmest gion in Germany; within spitting distance is Freibu which with its famous Gothic minster, old town a almost Mediterranean atmosphere is reminiscent places much further south. Stuttgart, the provinc capital, is emphatically industrious, with major cc cerns such as Bosch, Porsche and Daimler boosti the local economy.

Down in Bavaria, one institution which spectacula transcends local boundaries is Munich's Oktoberfe the biggest public festival in the world. From t jagged peaks of the Zugspitze and Watzmann mou tains to the green foothills of the Alps to Franco with its undulating hills and meandering riv Bavaria has a scenic diversity barely matched el where in Germany. Nuremberg, once a free city of Holy Roman Empire and home of the imperial rega and Würzburg, formerly a royal residence and seat the mighty prince-bishops, are just two cornersto in Bavaria's rich and varied history.

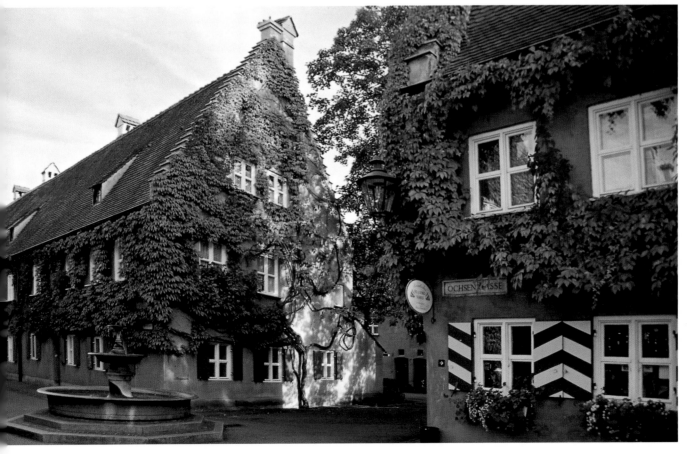

Above:
At the southernmost tip of the Mainviereck, tucked in between the forests of the Odenwald and Spessart, is Miltenberg with its castle of Miltenburg. The parish church of St Jakobus with its 19th century spires lines the road running alongside the river.

Left:
The Fuggerei, built in the 16th century with its 67 houses and 147 apartments, is the first social housing estate in the world. The yearly rent is still one Rhenish guilder or €0.88. In order to qualify for a flat here, you must have lived in Augsburg for at least two years, have got into serious difficulties through no fault of your own, be married and a Catholic. Tenants also have to say The Lord's Prayer every day – and a Hail Mary for the founder.

65

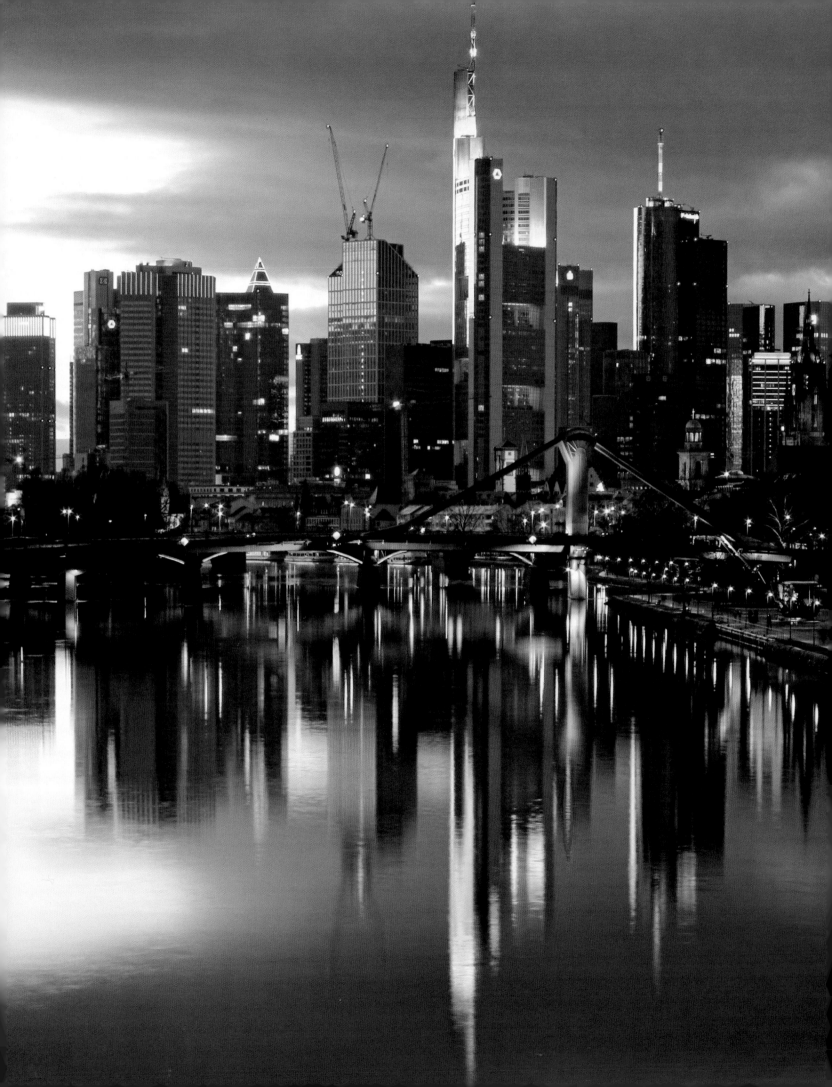

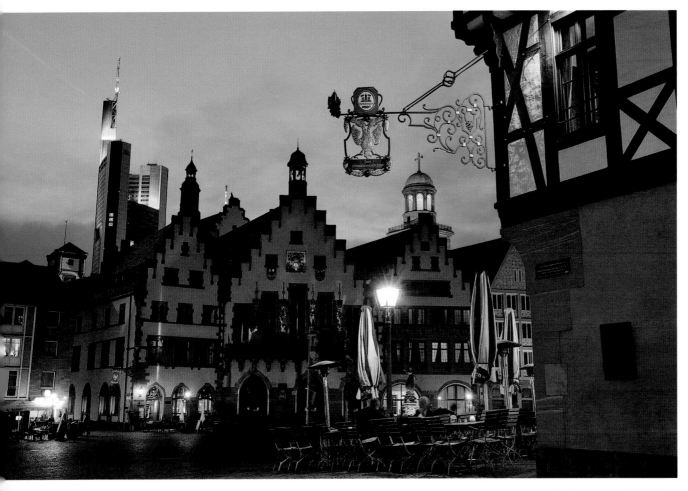

Left:
Römerberg is the historic
centre of Frankfurt.
The row of houses on the
east side of the square was
erected in the 1980s and
based on historic models,
reminding visitors of the
over 4,000 half-timbered
houses which once stood
here. The square has
always been a venue for
events on a large scale; in
the Middle Ages festivities
were held here to celebrate
the coronation of Ger-
many's emperors and
today football fans throw
spontaneous parties here
when the national German
team wins the match.

Left page:
The Frankfurt skyline is
unique in Germany and
underlines the city's
importance as a centre of
banking and trade. Frank-
furt was granted the right
to hold trade fairs here in
1240 and has been home
to the European Central
Bank since 1998. The city
is also a major cultural
and literary venue.

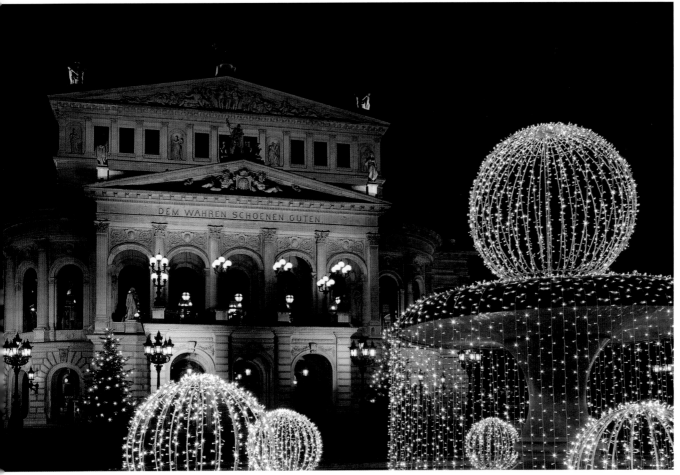

Left:
The Alte Oper in Frankfurt
am Main was financed by
the citizens of Frankfurt
and opened in 1881. Over
the course of its history the
opera house has seen many
premieres, including Carl
Orff's Carmina Burana in
1937. After being destroyed
in the Second World War,
it was reopened as a
concert hall in 1981.

Wiesbaden, the state capital of Hesse, sprawls from the foot of the Taunus Mountains to the banks of the River Rhine. With its 15 thermal springs the city is one of the oldest spas in Europe. On the left of the photo is the city palace of the house of Nassau, built in 1841, where the Hessian government now sits; in the centre is the Marktkirche and to the right the Neues Rathaus.

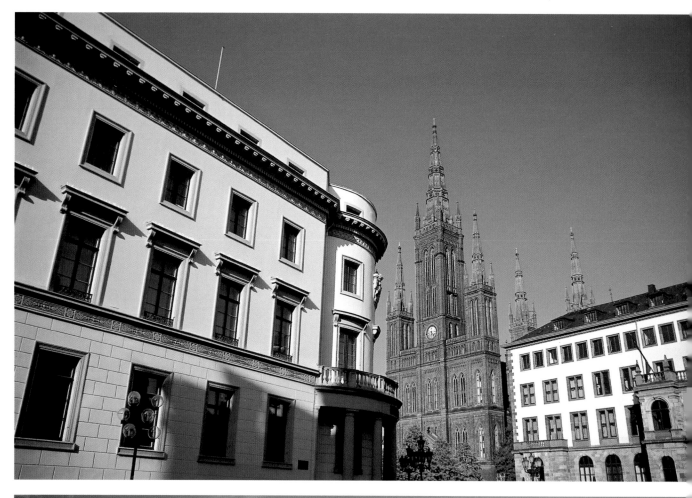

Zwingenberg on the Bergstraße was granted its town charter in 1274 and is a typical little town at the foot of the Odenwald, with chic half-timbered houses and narrow winding streets.

68

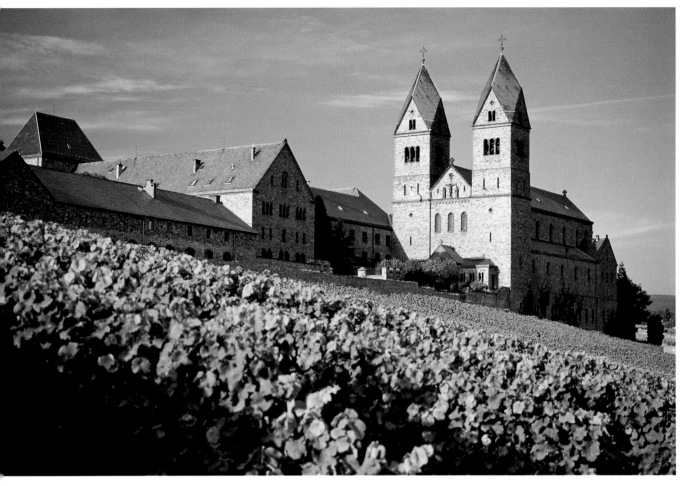

In the midst of the
Rheingau vineyards near
Eibingen is the abbey of
St Hildegard. The convent
was opened at the begin-
ning of the 20th century
by Benedictine nuns. The
community now works the
vineyards, a shop, a crafts
workshop and takes in and
looks after guests.

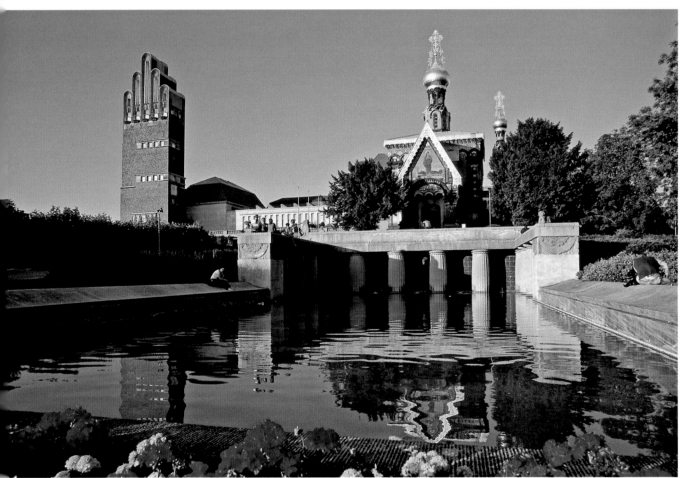

An artists' colony was
founded on Mathildenhöhe
in Darmstadt in 1899,
at the centre of which
stands Joseph Olbrich's
Hochzeitsturm or wedding
tower. The Russian chapel
adjacent to it seems out
of place in this complex
otherwise entirely devoted
to Jugendstil.

69

Speyer on the Rhine was originally a Roman settlement and during the Middle Ages one of the most important free imperial cities in the Kingdom of Germany in the Holy Roman Empire. Speyer Cathedral is the largest Romanesque church in the world still in existence and a world heritage site.

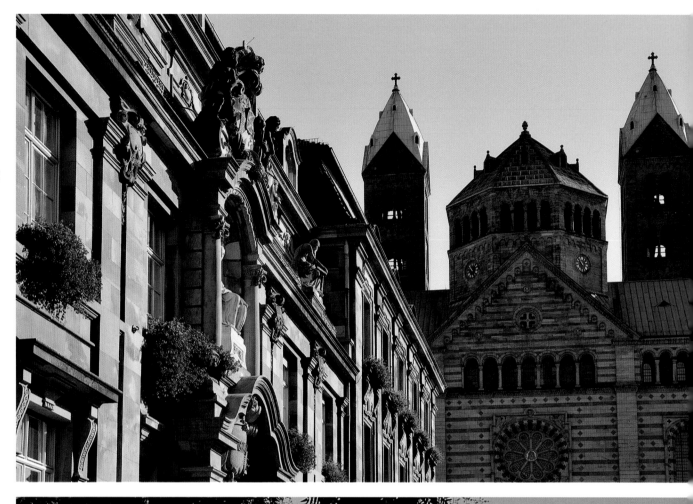

The most significant remnant of the Romanesque period in Mainz is its mighty cathedral, built from 975 to 1009 – and consumed by fire on the very day of its consecration. Over the centuries much has been added and amended – at the cost of a uniform architectural style. It is precisely this, however, which gives it its charm. Here the view from Leichhof.

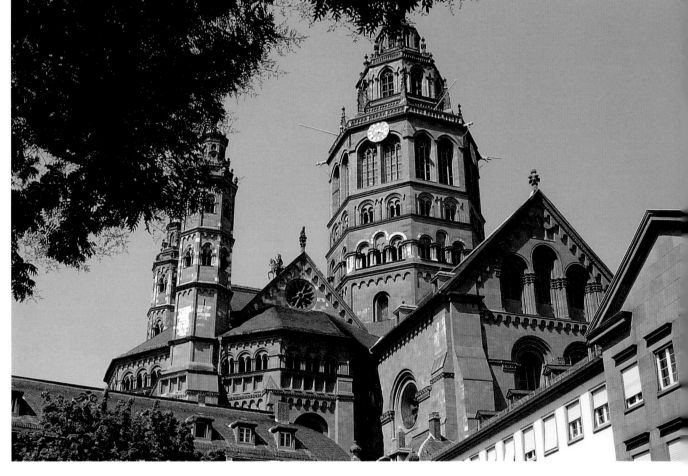

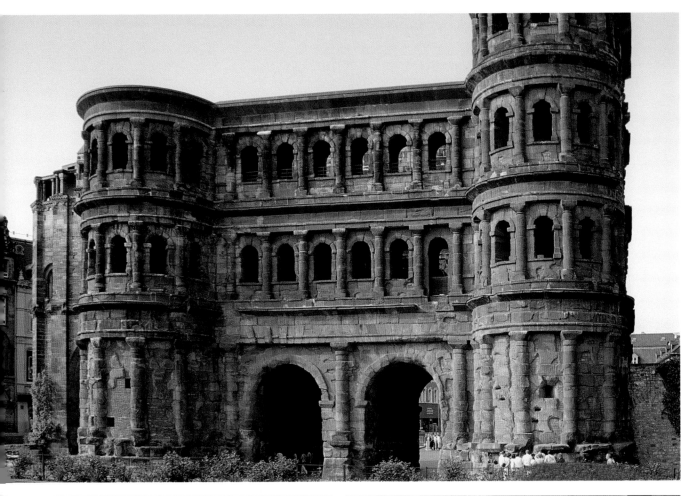

Trier was founded in 16 BC by Emperor Augustus and claims to be the oldest city in Germany. The Porta Nigra dates back to the 2nd century AD and was one of the main gates to the Roman city. The colossal defence was never completed, however. In the Middle Ages Greek monk Simeon settled here; the Simeonstift collegiate was later erected in his honour and the Roman gate used as a twin church. Two places of worship were fabricated from the structure, one on top of the other; one of the apses is still visible.

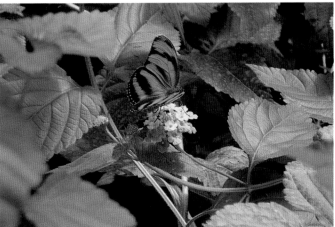

The origins of Schloss Sayn in Bendorf on the Rhine go back to the 14th century. The present palace is 19th century. It has many attractions, one of them its unique butterfly garden, where you can study hundreds of exotic moths and butterflies up close.

71

The imperial fortress of Cochem has dominated the town of the same name on the River Moselle since 1070. Its present guise is a product of the 19th century when the ruin was resurrected in the neo-Gothic vein. The Rittersaal, the old knight's hall, is of particular note.

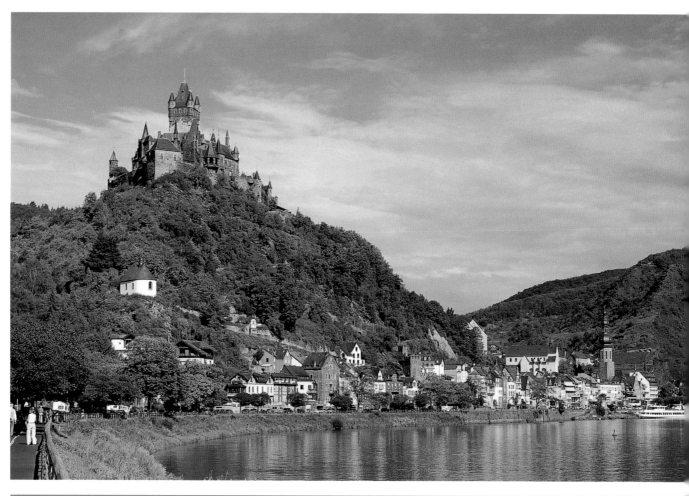

Burg Eltz in the Vordereifel is one of the loveliest and best preserved castles in Germany. The fortress dates back to the 13th century and was frequently extended down the centuries. Eltz is now privately owned.

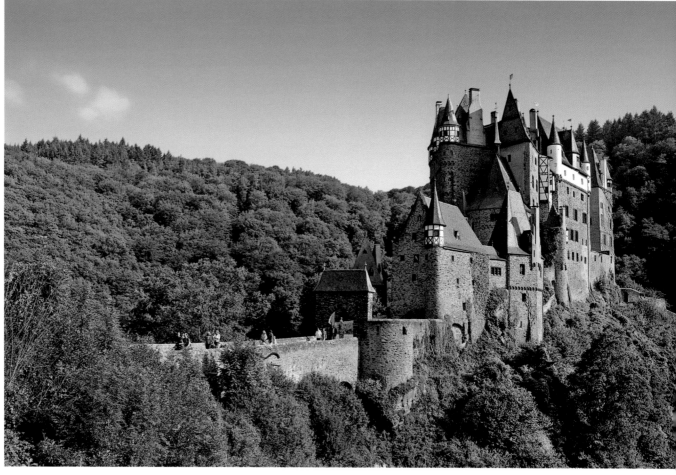

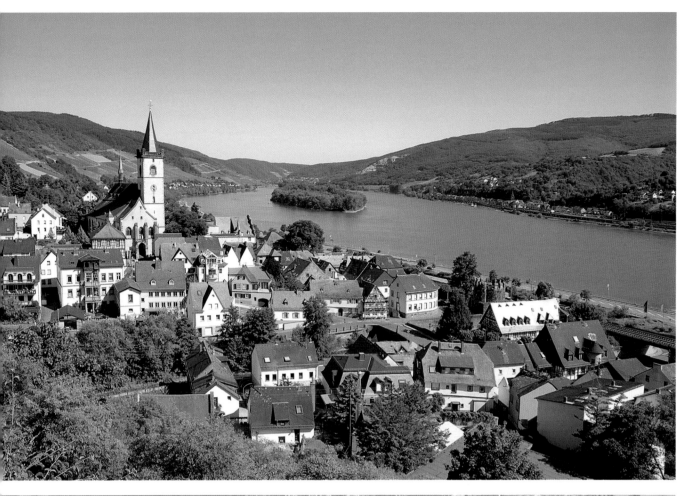

Lorch enjoys a scenic setting on the banks of the Rhine between Rüdesheim and St Goarshausen. Before it lie the churning waters of Father Rhine, beyond it lush vineyards growing delicious Rhine wine. The two islands in the middle of the river are a nature conservation area.

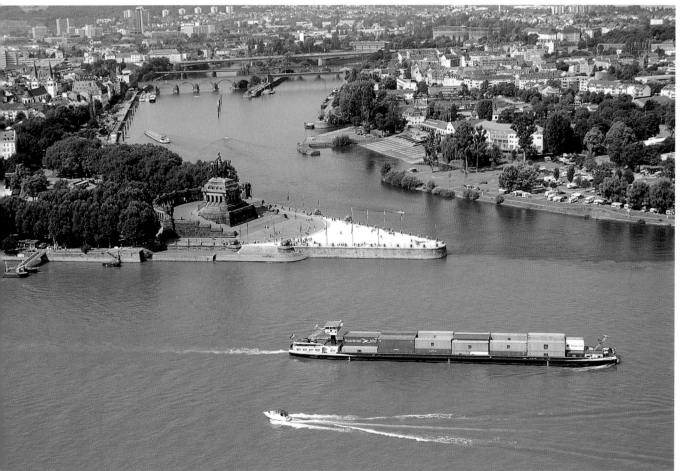

The Moselle flows into the Rhine at the Deutsches Eck in Koblenz. This marked spit of land is dominated by a statue of Kaiser Wilhelm, restored in 1993. After its destruction in the war only the base was reconstructed to remind visitors of the fact that then Germany was divided.

Page 74/75:
Heidelberg is at its most scenic viewed from Philosophenweg. Its setting on the River Neckar, with its enormous castle and historic old town with the Heiliggeistkirche, is without equal.

73

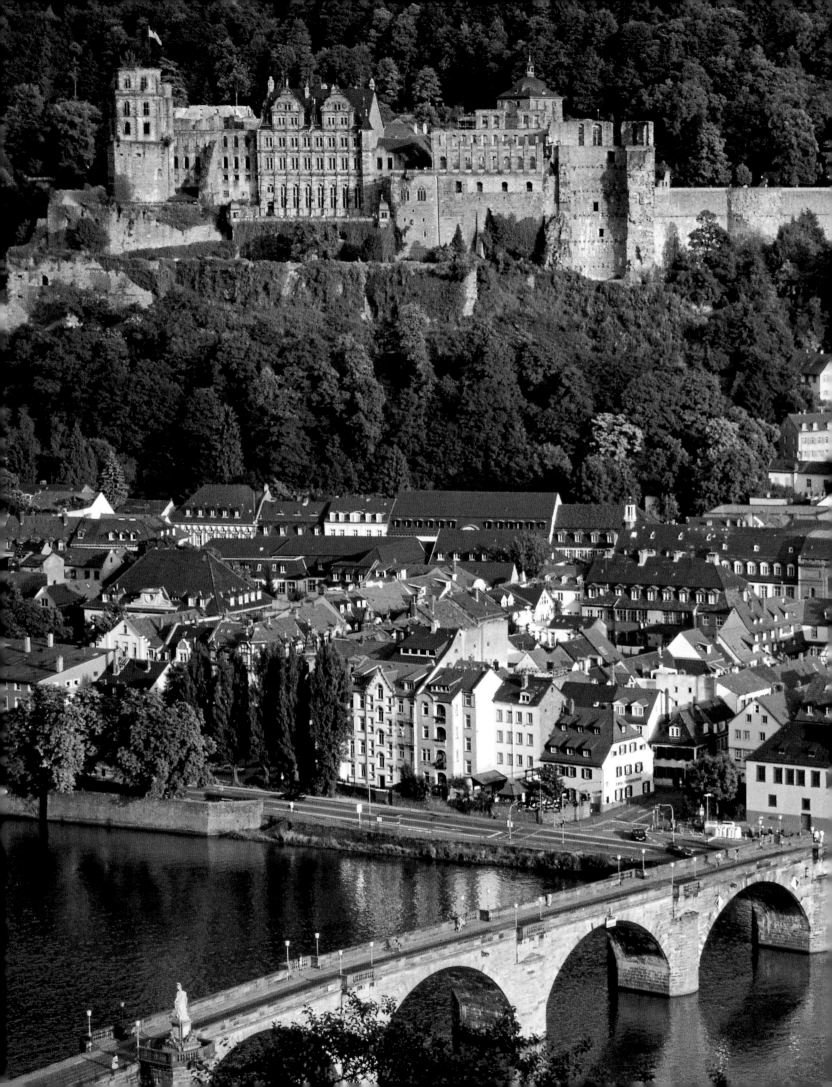

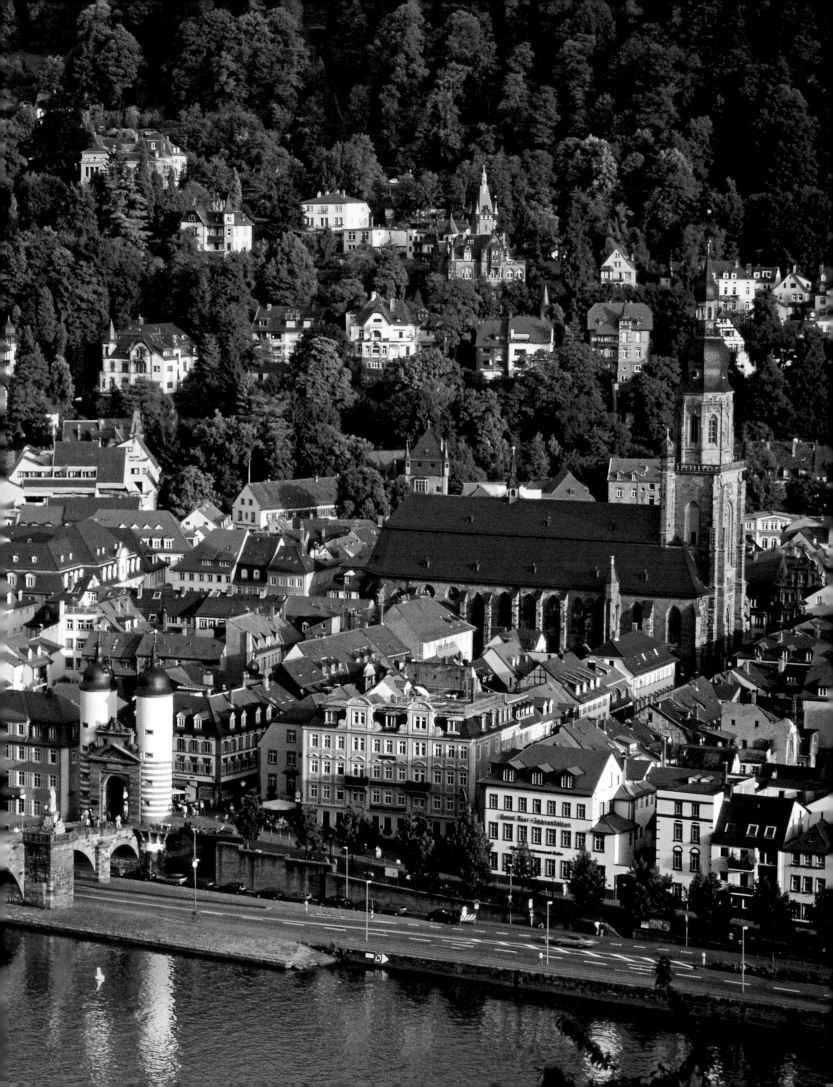

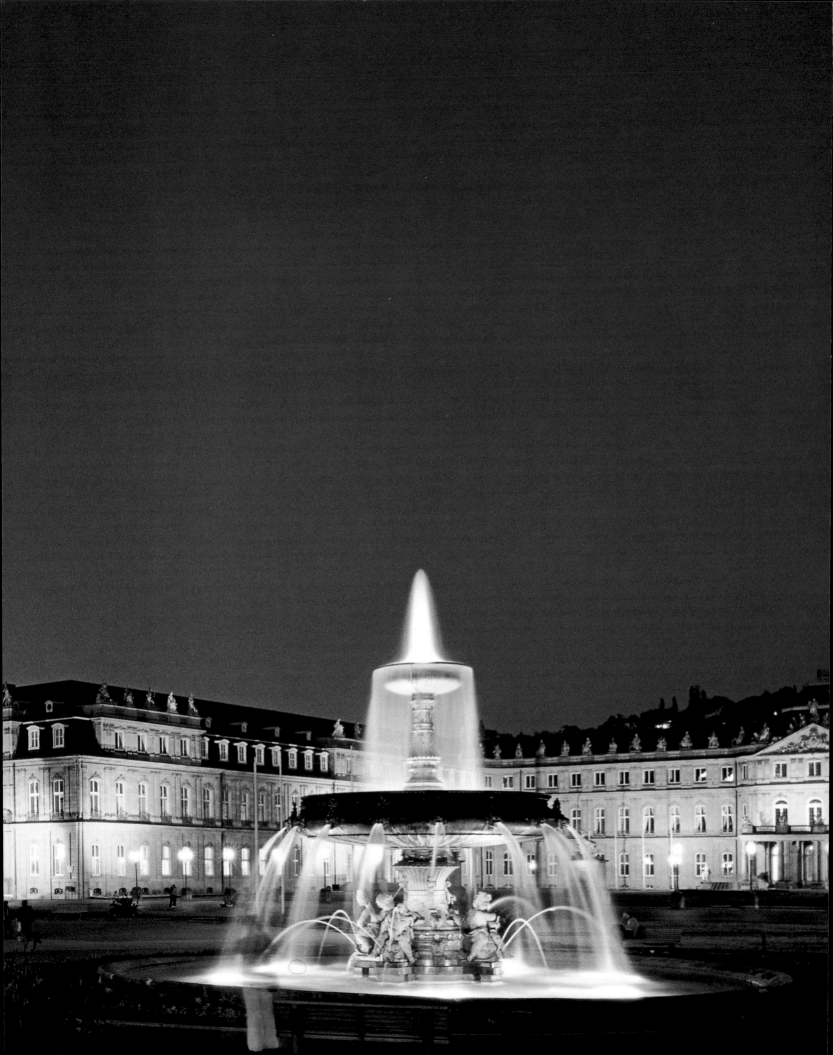

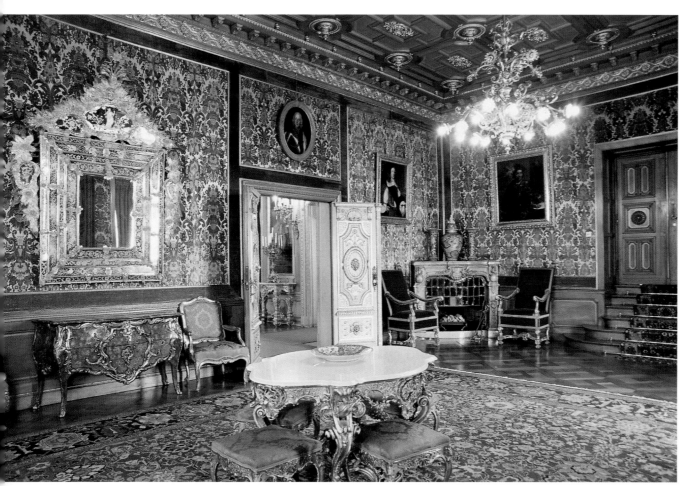

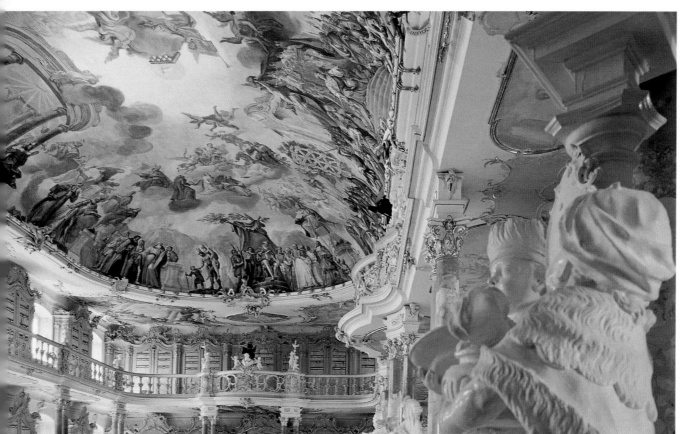

Left:
The history and confidence of Sigmaringen is mirrored in the mighty stronghold which squats atop a rocky spur high up above the River Danube. Its foundations date back to the 12th century and its various extensions to the Renaissance, with the chief percentage of its fabric "Romanesque" restorations executed by Munich architect Emanuel von Seidl following a fire in 1893. The state rooms in Schloss Sigmaringen are now furnished with a melange of old and new.

Left page:
Schlossplatz is the showpiece of Stuttgart. The Neues Schloss, almost completely destroyed during the Second World War, was rebuilt from 1956 to 1964 and the park redesigned in the spirit of the baroque for the 1977 Bundesgartenschau or national garden exhibition.

Left:
In the library room at the monastery of Bad Schussenried Franz Martin Kuen (ceiling fresco) and Dominikus Hermenegild Herberger (sculptures) paid homage to monastic virtues and worldly sciences – and to the wisdom of God, which they honoured in their works through allegory.

The 'bright blue' water of the Blautopf near Blaubeuren, a karst spring on the Schwäbische Alb, has always fascinated people. In heathen times there was allegedly a religious site here; the arrival of Christianity saw the building of a church. Eduard Mörike and folk legend believed there to be "water nymph with long, flowing hair" in its depths.

From the old fortress at Meersburg there are spectacular views of Lake Constance, with the Swiss Alps visible on a clear day. Poet Annette von Droste-Hülshoff lived and worked at the castle over 150 years ago. The Altes Schloss now contains a museum in her name.

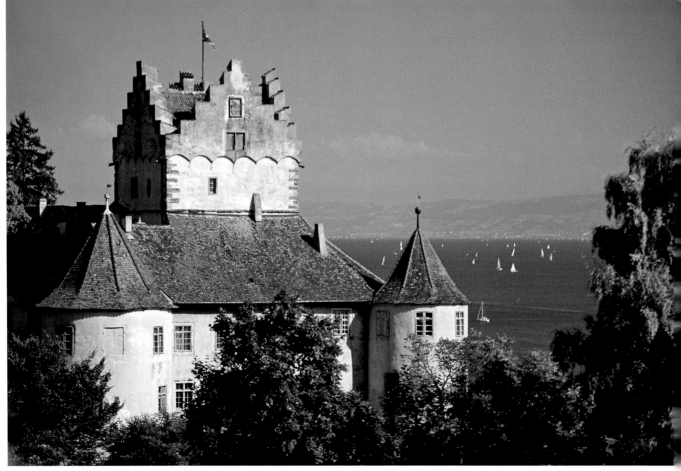

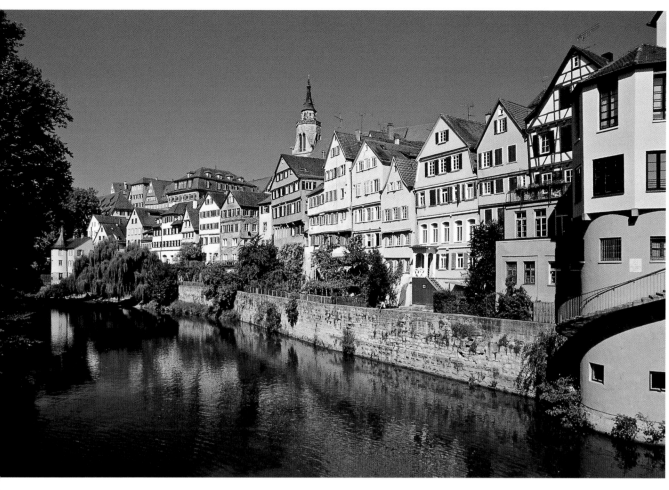

After Stuttgart Tübingen on the River Neckar is the most historically important city in Württemberg. Through the founding of its university in 1477 and the Evangelical collegiate in the old Augustinian monastery in 1547, the epitome of Swabian intellectuality, it became one of the chief scholarly centres of the land. The photo shows the Neckar and the Hölderlinturm (left) where poet Friedrich Hölderlin lived to the end of his days.

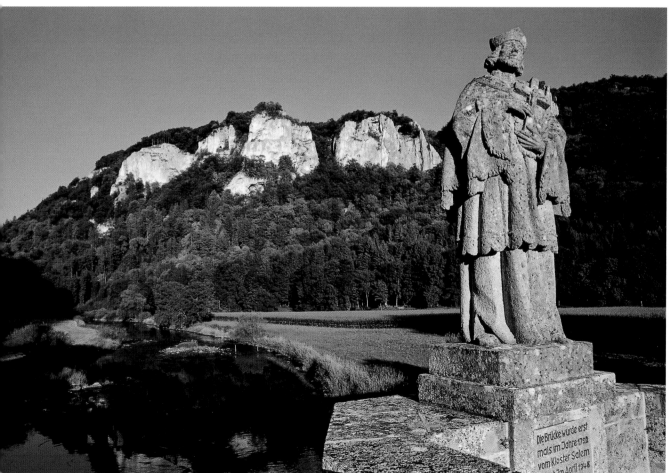

Two mighty walls of rock tower above a narrow channel of the Danube near Hausen im Tal. The northerly of the two is crowned by Schloss Hausen. The cliffs are an eldorado for climbers and the area boasts plenty of great trails for hikers.

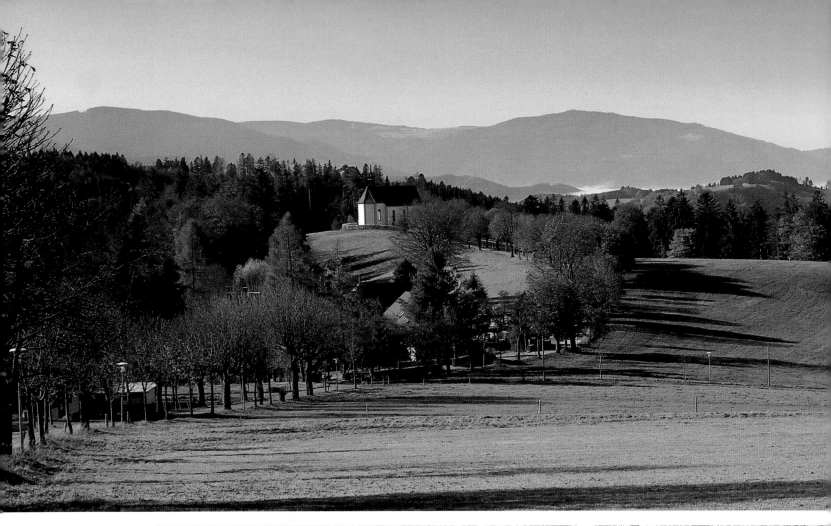

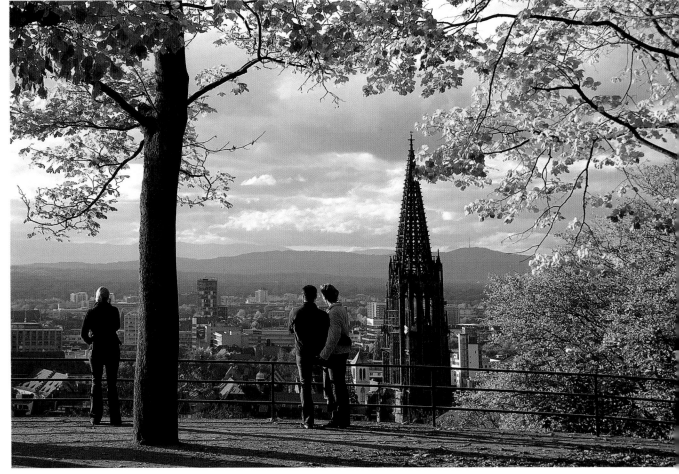

Above:
From St Märgen in the Black Forest walkers can gaze out over rippling autumn fields to the elevations of Feldberg Mountain. Down in the valleys of Höllental and Dreisamtal the fog often lingers all day, prompting people from nearby Freiburg to escape to the hills for some warm autumn sunshine.

Right:
From Kanonenplatz there are grand views of Freiburg and the hustle and bustle of the city. At this height onlookers are as tall as the Gothic steeple of Freiburg's Minster, giving them a new perspective on this magnificent piece of architecture.

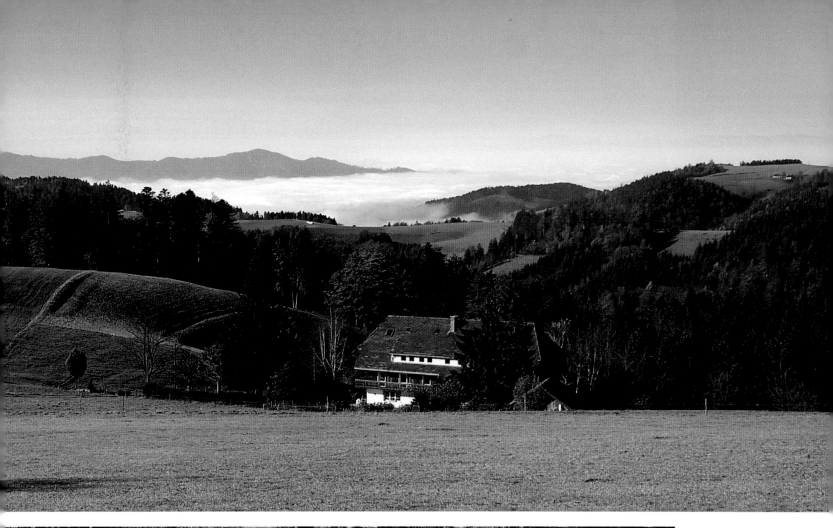

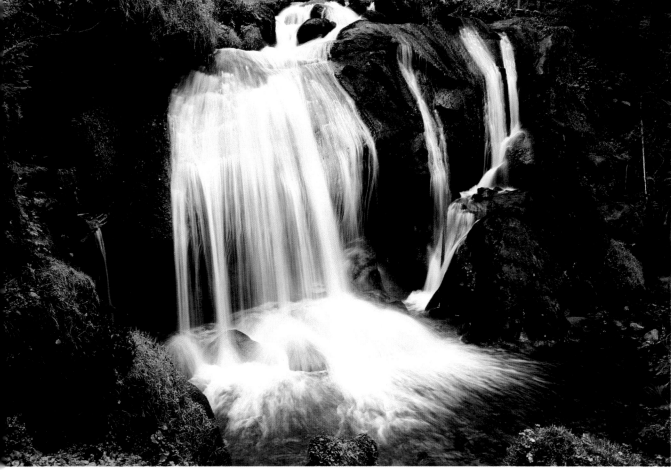

Left:
The Black Forest, with its abundance of woods and water, is where Germany's highest waterfalls cascade down the rocky mountainside. At Triberg the River Gutach has a spectacular drop of 162 meters (532 feet).

"Alter Peter" is the fond nickname the people of Munich have given the oldest parish church in town, St Peter's, which had to be completely rebuilt following the bombings of the Second World War. From the top of the steeple you can watch the goings on down on Marienplatz and at the Rathaus and Frauenkirche.

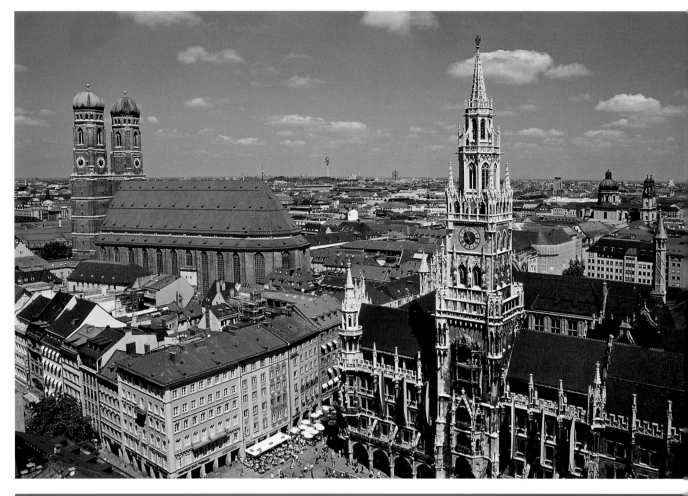

Schloss Nymphenburg in Munich, with its unique composition of palace and gardens, is considered to be one of the most beautiful palaces in the world. In 1664 Elector Ferdinand Maria commissioned the building as a gift for his wife Adelheid of Savoy after she had borne him the long-awaited heir to the throne, May Emanuel.

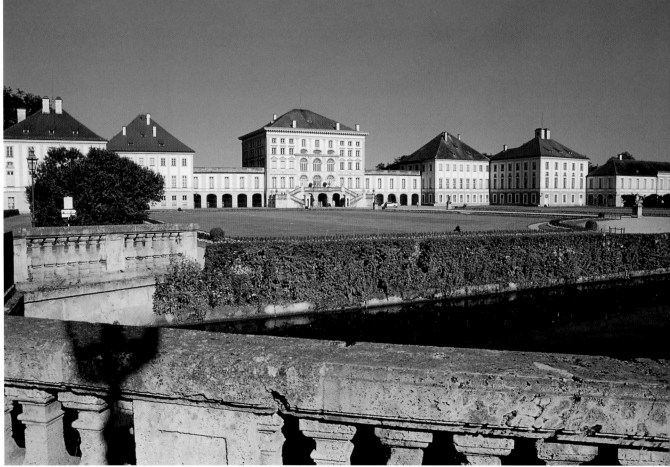

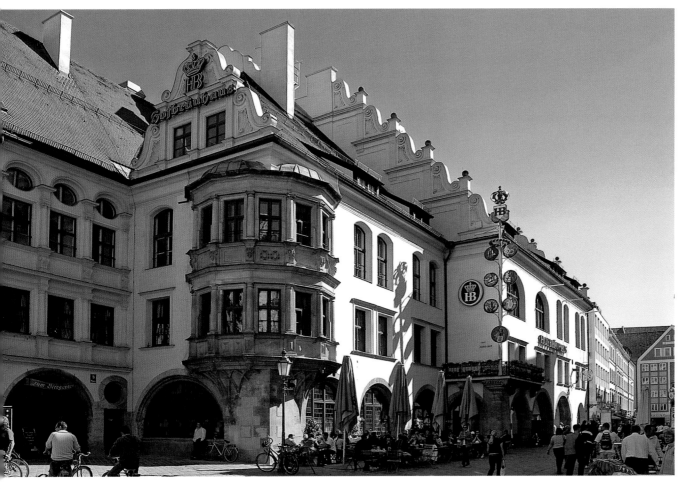

Munich's most famous building can be found Am Platzl. Beer has been served at the Hofbräu-haus, long also the site of the Hofbräu brewery, since 1589. There was also a theatre here on the square which until 1994 was a popular venue for folk singers.

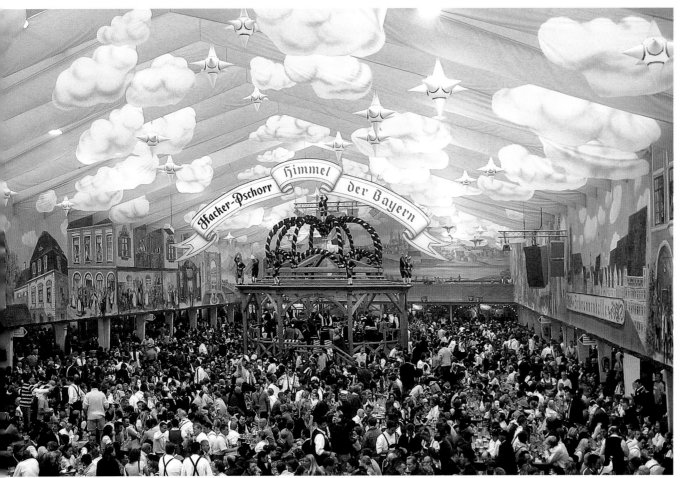

Munich's Oktoberfest started out as a simple steeple chase staged to celebrate the wedding of the then crown prince and later king Ludwig I and Therese von Sachsen-Hildburghausen on October 17, 1810. The grand festival now opens with a colourful parade, headed by champion riflemen, publicans, oompah bands and groups in local costume. On arrival at the Theresienwiese fairground Munich's lord mayor ceremoniously taps the first barrel of beer to the much-awaited cry of "O'zapft is!". This heralds the start of the jollities which last for two heady weeks, during which Munich and the rest of the world throng to the beer tents to quench their thirst and still their hunger with beer, white sausages, beer, pig's trotters, roast ox on a spit – and yet more beer.

83

Rothenburg ob der Tauber is the epitome of the medieval city, its half-timbered dwellings and thick walls once impenetrable. Following a major boom in the 14th century the money soon ran out and the town (luckily) escaped the usual modernisations of later centuries.

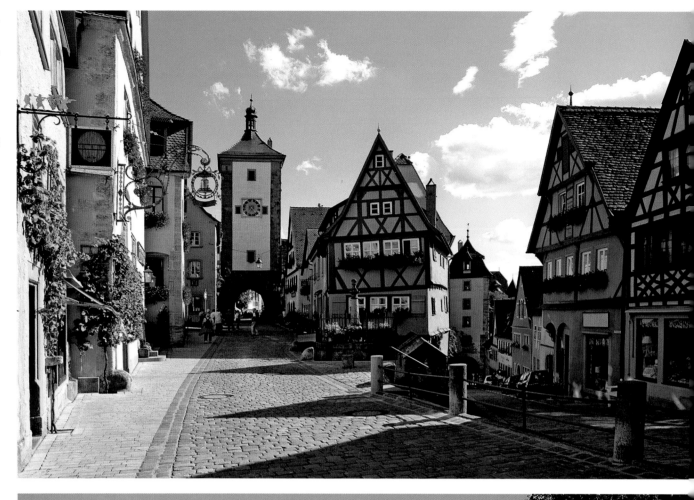

One of the most impressive half-timbered structures in Nuremberg is the Weinstadel on the River Pegnitz which was built in the mid 15th century as an infirmary. Wine was stored here from 1528. The Wasserturm next to it was once part of the city fortifications.

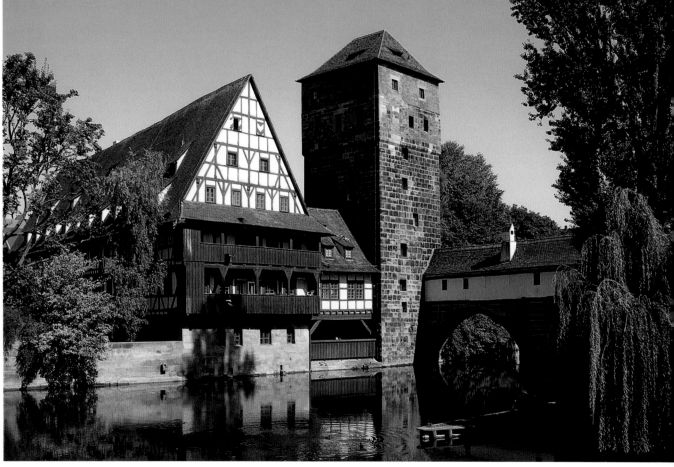

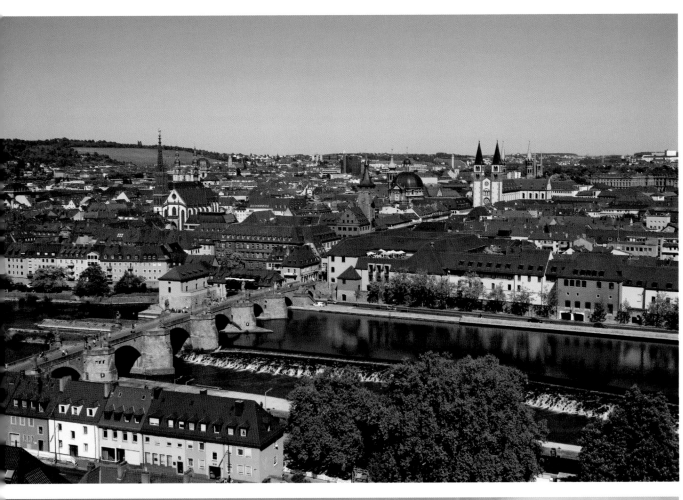

The Alte Mainbrücke in Würzburg links the old town with the Mainviertel from whence you can see Grafeneckart, the tower of the Rathaus (right), and the Domstrasse which culminates in the twin spires of the Kiliansdom (far right). The twelve figures on the bridge represent the saints closely connected with Würzburg, among them Scottish monk St Kilian who introduced the city to Christianity in the 7th century.

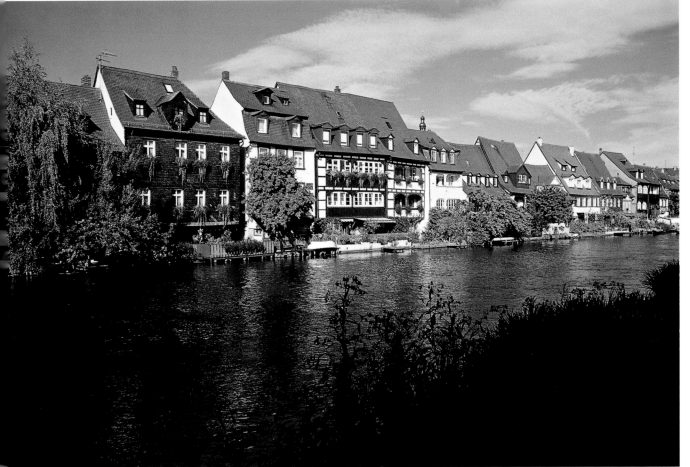

This idyllic row of houses along the Regnitz in Bamberg, each with its own landing stage, is reminiscent of Venice, hence the name "Little Venice". This is where Bamberg's skippers and fishermen once lived, with work guaranteed by the busy shipping trade along King Ludwig's old Main-Danube canal.

Page 86/87:
The most famous castle in Germany – if not in the world – is Schloss Neuschwanstein, made all the more spectacular by its memorable setting. Its builder, King Ludwig II, had Richard Wagner's opera Lohengrin in his mind's eye when he had his dream castle erected on the ruins of Burg Vorderschwangau.

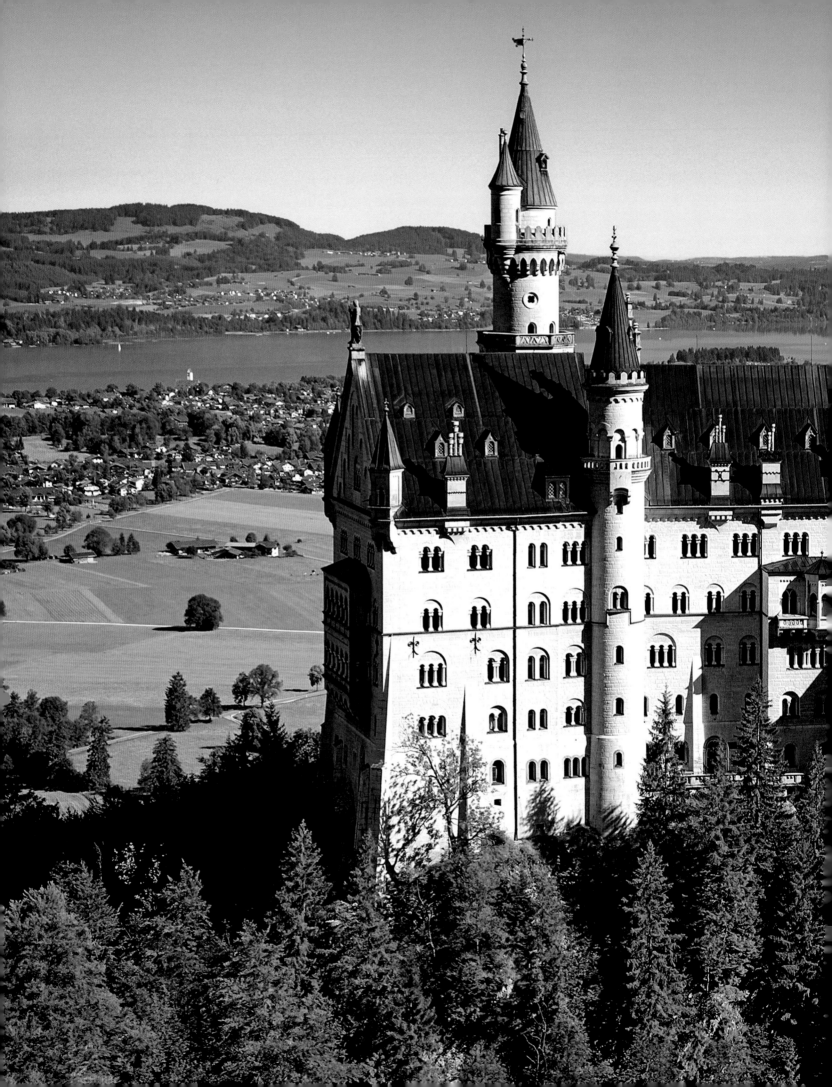

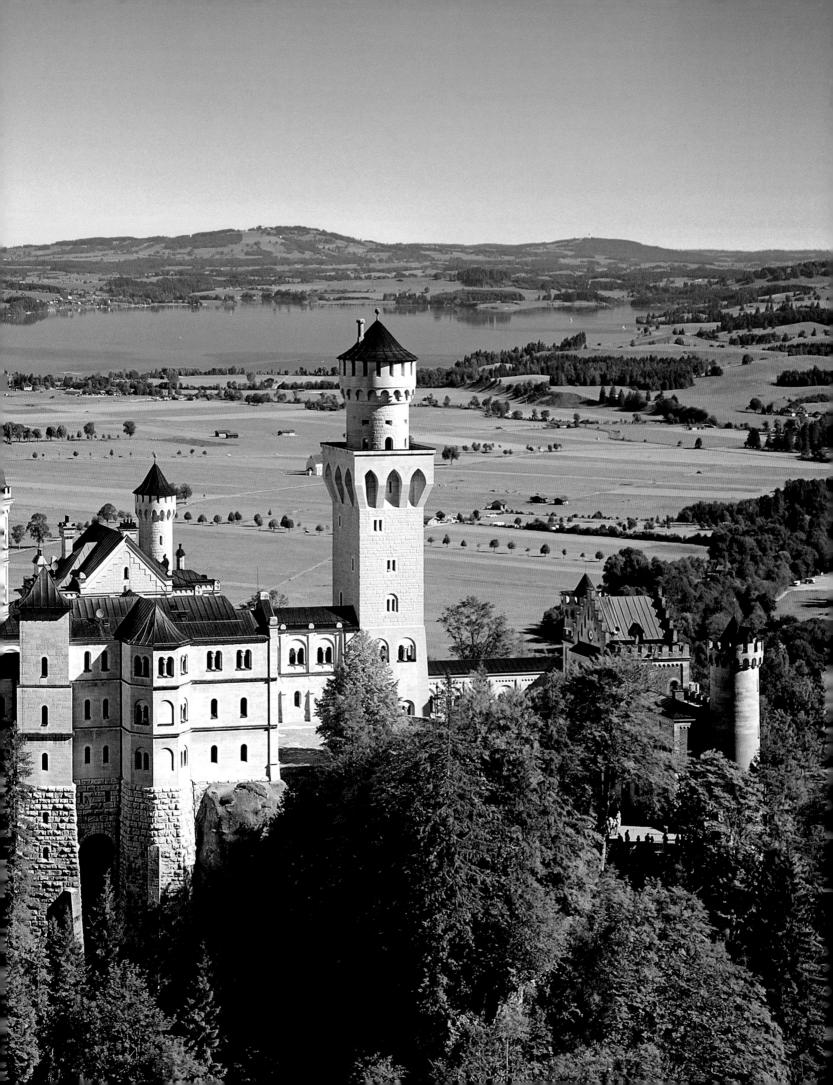

Looking up from a spring meadow near Garmisch-Partenkirchen to the snowy peak of the Zugspitze, at 2,962 m (9,718 ft) the highest mountain in Germany. To the right is the Alpspitze, 2,628 meters (8,622 feet) above sea level.

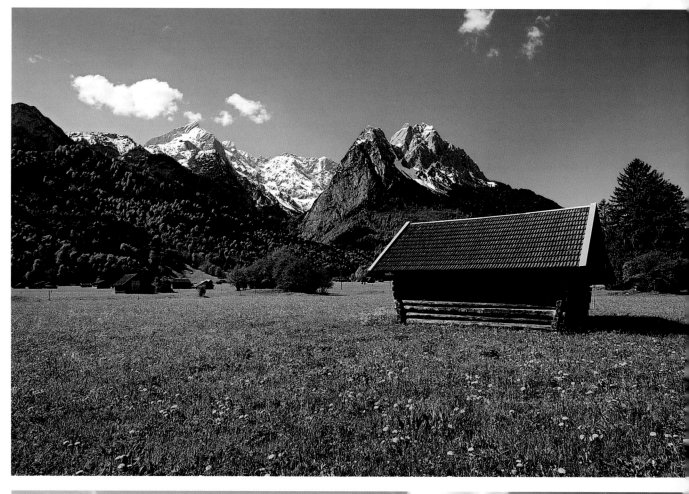

The Königsee with its pilgrimage church of St Bartholomä huddled beneath precipitous cliffs of chalk is one of the gems of the Berchtesgadener Land. The unmistakable edifice has been a place of pilgrimage since the 12th century.

Right page:
The gloriously situated parish church dedicated to St Fabian and St Sebastian in Ramsau is one of the most famous houses of God in the Bavarian Alps. It was built in 1512 and later baroqueified. Its spire cupola and setting make it something of a local landmark.

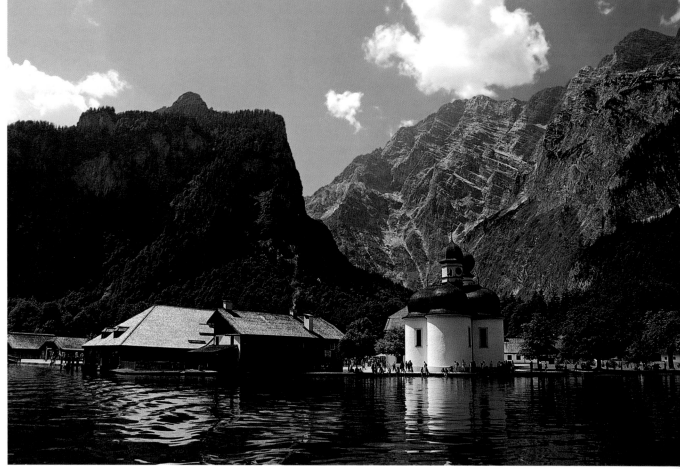

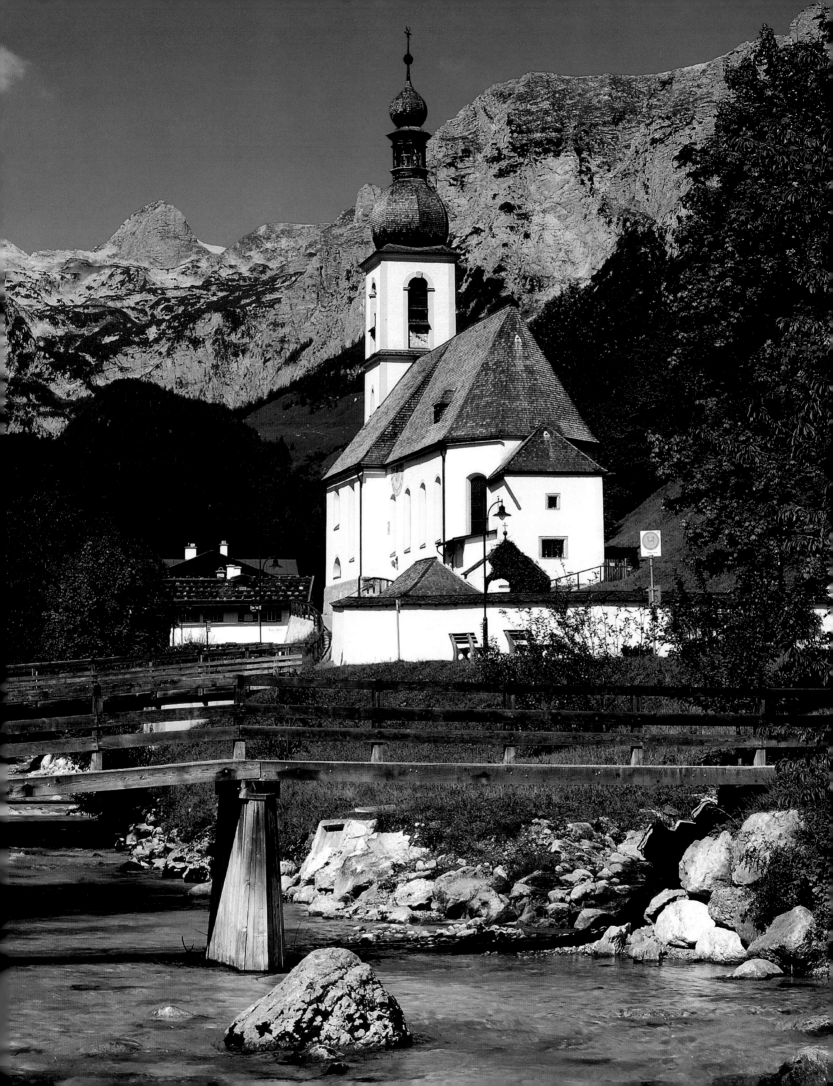

REGISTER

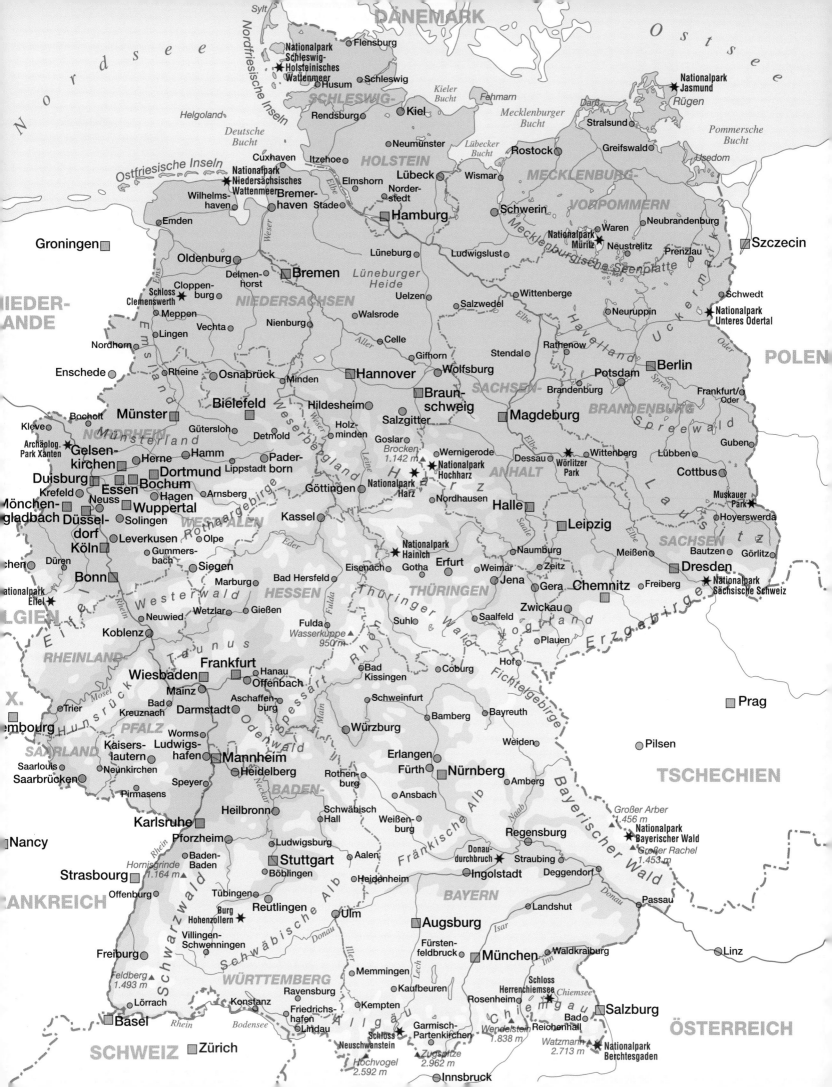

Franconia's fairytale castle is called Mespelbrunn and lies hidden deep in the forest of the Spessart. This is where Julius Echter was born in 1573, who as prince-bishop of Würzburg not only founded a famous hospital but also launched the Counter-reformation with great aplomb.

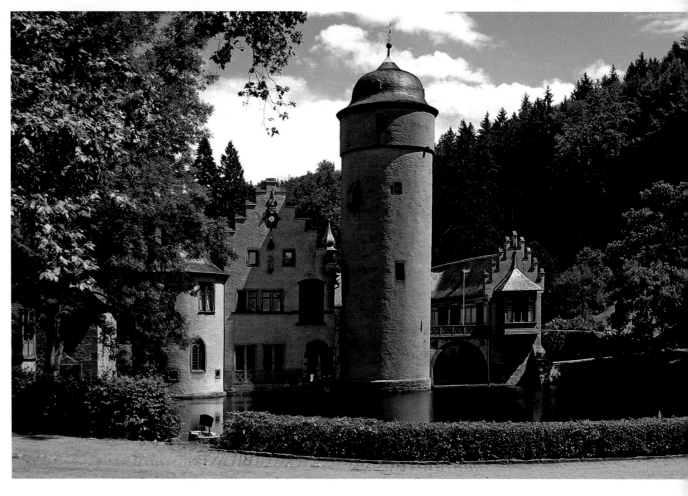

Front cover:

Top:
These wicker chairs on Amrum offer welcome protection from the stiff sea breeze.

Bottom:
Fairytale Schloss Neu-schwanstein clings to a rocky spur high up above the wide expanses of the Allgäu.

Back cover:
Rothenburg ob der Tauber has managed to retain its unique medieval charm, its streets lined with half-timbered houses and stone gateways. Here the Seiberstor (left) and Kobolzellertor (right).

PUBLISHER'S NOTES

Design
hoyerdesign grafik gmbh, Freiburg
www.hoyerdesign.de

Map
Fischer Kartografie, Aichach

Translation
Ruth Chitty, Stromberg
www.rapid-com.de

Printed in Italy
Repro by Artilitho snc, Lavis-Trento, Italy
www.artilitho.com
Printed/Bound by Grafiche Stella srl, Verona, Italy
© 4th edition 2015
 Verlagshaus Würzburg GmbH & Co. KG
© Photos: Tina and Horst Herzig
© Text: Sebastian Wagner

ISBN 978-3-88189-003-8

Details of our full programme can be found at:
www.verlagshaus.com

PICTURE CREDITS

Tina & Horst Herzig:
P. 5, p. 8/9, p. 12/13, p. 15, p. 16, p. 17, p. 24 top, p. 31 bottom, p. 37 top, p. 48 top, p. 48 botto p. 49 top, p. 49 bottom, p. 50 top, p. 50 bottom, p. 51 top, p. 51 bottom, p. 54 top, p. 54 botton p. 55, p. 56 top, p. 56 bottom, p. 57 top, p.57 bottom, p. 58 top left, p. 58 top right, p. 58 botton p. 59 top, p.59 bottom, p. 60 top, p. 60 bottom, p. 61 top, p. 61 bottom, p. 62 top, p. 62 bottom p. 63 top, p. 64/65 top, p. 65 bottom, p. 67 top, p. 67 bottom, p. 68 top, p. 68 bottom, p. 69 top p. 69 bottom, p. 70 top, p. 74/75, p. 76, p. 77 top, p. 77 bottom, p. 78 top, p. 78 bottom, p. 79 t p. 79 bottom, p. 82 top, p. 82 bottom, p. 85 bottom.

Other:
Top front cover: Angelika Stern/iStockphoto.com; bottom front cover: iStockphoto.com; bac cover: Steffi Langer/iStockphoto.com; p. 6/7: Dirk Freder/iStockphoto.com; p. 10/11: Gabriele Weschke/iStockphoto.com; p. 14: Guido Roesen/fotolia.com; p. 18/19: Ingmar Wesemann/iSt photo.com; p. 20/21 top: Lothar Lorenz/fotolia.com; p. 21 bottom: Angelika Stern/iStockphoto. p. 22 top: p. Lutz/digitalstock.de; p. 22 bottom: Wolfgang Mette/fotolia.com; p. 23 top: O. Ma digitalstock.de; p. 23 bottom: Harald Bolten/iStockphoto.com; p. 24 bottom: Christoph papke iStockphoto.com; p. 24 top: Thomas Lammeyer/fotolia.com; p. 25 bottom: Matthias Krüttgen fotolia.com; p. 26/27 top: H.-Joachim Boldt/digitalstock.de; p. 26 bottom: A. Fotoman/digitalstoc p. 27 bottom: Lucyna Koch/iStockphoto.com; p. 28 top: V. Dominiczak/digitalsock.de; p. 28 bo left: Guide Roesen/digitalstock.de; p. 28 right: Guide Roesen/digitalstock.de; p. 29 top Rauch/digitalstock.de; p. 29 bottom: p. Fuchs/digitalstock.de; p. 30/31 top: Thomas Vogel/iSt photo.com; p. 30 bottom: Heinz Tschanz-Hofmann/iStockphoto.com; p. 32: Martina Berg/fotolia p. 33 top: Hans Klamm/iStockphoto.com; p. 33 bottom left: H. Adam/digitalstock.de; p. 33 bot right: Martina Berg/fotolia.com; p. 34/35: Sean Pavone/iStockphoto.com; p. 36 top: Peter Frai iStockphoto.com; p. 36 bottom: Knut Dr. Haehn/iStockphoto.com; Carme Ballsells/iStockphoto. p. 38/39 top: iStockphoto.com; p. 38 bottom: Andreas Weber/iStockphoto.com; p. 39 bottom Richard Schmidt-Zuper/iStockphoto.com; p. 40/41: delray77/iStockphoto.com; p. 42/43 top: Mat Dixon/iStockphoto.com; p. 43 bottom: Philip Lange/iStockphoto.com; p. 44 top: A. Rohrhofe digitalstock.de; p. 44 bottom left: Mikael Lyk Madsen/iStockphoto.com; p. 44 centre right: Ai Globisch/iStockphoto.com; p. 44 bottom right: Frank van den Bergh/iStockphoto.com; p. 45 A. Rohrhofer/digitalstock.de; p. 45 bottom: Alex Slobodkin/iStockphoto.com; p. 46 top: Dair Derics/iStockphoto.com; p. 46 bottom: Elena Korenbaum/iStockphoto.com; p. 47 top: Jockel digitalstock.de; p. 47 bottom: D. Möbius/digitalstock.de; p. 52/53: ZU_09/iStockphoto.com; p Michael Opper/pixelio.de; p. 63 bottom: iStockphoto.com; p. 70 bottom: Heiko Bewnnewitz/ iStockphoto.com; p. 71 top: iStockphoto.com; p. 71 bottom left: Melanie Zeuß, p. 71 centre r Melanie Zeuß, p. 71 bottom right: Melanie Zeuß; p. 72 top: Anja Frost/iStockphoto.com; p. 7 bottom: iStockphoto.com; p. 73 top: Olga Shelego/iStockphoto.com; p. 73 bottom: Melanie Z p. 80/81 top: Dr. Heinz Linke/ iStockphoto.com; p. 80 bottom: Heinz Linke/iStockphoto.com; p bottom: Wolfgang Fischer/ iStockphoto.com; p. 83 top: G. Brochon/digitalstock.de; p. 83 bott A. Fotoman/digitalstock.de; p. 84 top: Steffi Langer/iStockphoto.com; p. 84 bottom: Karl-Fried Hohl/iStockphoto.com; p. 85 top: Jürgen Roth; p. 86/87/iStockphoto.com; p. 88 top: iStockphoto.com; p. 88 bottom: Sándor Kelemen/iStockphoto.com; p. 89: Thorsten Karock/iStockphoto.com; p Dieter Krause.

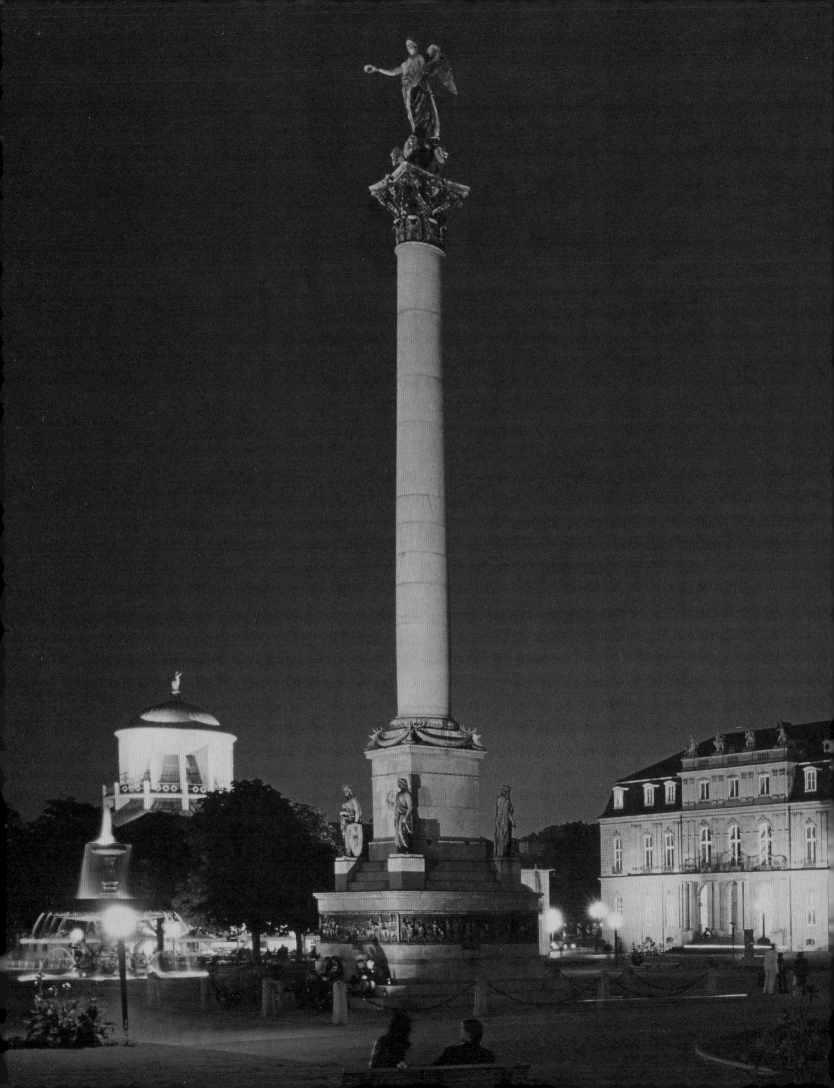